Fun and Friendly

Calligraphy

for Kids

A Hands-On Guide to Creative Lettering

Virginia Lucas Hart

Ulysses Press

Published in the United States by:
Ulysses Press
P.O. Box 3440
Berkeley, CA 94703
www.ulyssespress.com

ISBN: 978-1-61243-722-4
Library of Congress Control Number: 2017937990

Printed in the United States by Bang Printing
10 9 8 7 6 5 4 3 2 1

Acquisitions editor: Bridget Thoreson
Managing editor: Claire Chun
Editor: Shayna Keyles
Proofreader: Renee Rutledge
Front cover design: Virginia Lucas Hart
Cover art: © Virginia Lucas Hart except blank paper tablet (front) © Bennyartist/shutterstock.com
 and birthday card (back) © Mateusz Gzik/shutterstock.com
Interior design and layout: what!design @ whatweb.com
Interior art: © Virginia Lucas Hart except © Minnow Park (minnowpark.com) pages 14–15, 20, 22,
 24, 25, 26, 28, 29, 35, 49, 74, 92, 93, 97, 98, 99, 115; © Naomi Davis page 120

Distributed by Publishers Group West

I dedicate this book
to my oldest brother,
Chris
who not only inspired
me at a young age with
his beautiful calligraphy,
but also encouraged me to
use and cherish the most
important tool available:
my imagination.

"Calligraphy is an art form that uses ink and a brush to express the very souls of words on paper."

—Kaoru Akagawa

"Lettering creates readable art that comes to life, displaying a quirky, whimsical nature."

—Peggy Dean

"Addison spoke in calligraphy while everyone else talked in scribbles."

—Shawn Martin, author of *Shadowflesh*

this book belongs to:

Contents

a b c d e a b c d e

f g h i j f g h i j

k l m n o k l m n o

p q r s t p q r s t

u v w

x y z

v u w x y z

a b c d e f g

a b c d e f g h h i j k l m n

i j k l m n o p o p q r s t u

q r s t u

v w x y z v u w x y z

Introduction

Well, hello! I'm so glad you picked up this book, but maybe you're wondering if this book is right for you. Let me see if I can help answer that question.

- Are you a kid who loves to doodle?
- Do you find yourself rewriting your name over and over and over again, because it's fun to make it look all sorts of different ways?
- Do you enjoy writing and drawing so much that it's all you want to do in your spare time? Or, do you maybe-kinda-sorta-sometimes enjoy writing and drawing, but you'd like to expand your skills?
- Do you absolutely despise anything to do with writing and drawing, but maybe you're a little bit curious about calligraphy? Or, maybe you've tried calligraphy before and found it kind of intimidating, but you want to give it another shot?
- Are you a tween, a teen, or an adult who stumbled across this book and thought "this looks kind of fun," even if you're not a kid?

If you answered "yes" to any of the above, this book is for you!

Where to Begin

Now that we've got that cleared up, let's talk about what calligraphy even means. The definition of calligraphy is "beautiful or decorative handwritten lettering," or, in other words, pretty handwriting.

Just like fingerprints, no two people have the same handwriting. I want you to think about that for a second. With over 7 billion people in this world, your handwriting is uniquely yours. How cool is that? It's surely something to celebrate. Even if you practice others' styles, your exact handwriting is always going to be slightly different from everyone else's, depending on the weight of your lines and how you draw each and every section of a letter. That's another important thing to remember: You're not simply writing the letters, you're drawing them.

When you hold the calligraphy pen in your hand for the first time, I want you to forget everything you've learned about holding a writing utensil and how to form letters. I want you to imagine that, instead, you're holding a paintbrush. A magical one.

Handwritten (or hand-drawn) words are ultimately a form of communication. I like to think that mumbling, scribbled notes, and texting are all in the same category, but they're just one end of the communication spectrum. On the other end of the spectrum, there's singing, handwritten letters, and calligraphy, which all contribute an added layer of beauty and specialness to the meaning of the words.

So, what's the purpose of this book? This book will teach kids and other beginners everything they need to know to get started with two forms of modern lettering: pointed pen and brush calligraphy. We'll walk through the common strokes and shapes of the letterforms, go through each letter of the alphabet, and eventually build up to piecing together words and phrases. This book will give you the resources to set up your workspace and care for your tools, learn the key basics, practice different lettering styles and techniques, and put your new skills to use in fun, creative projects. The options for calligraphy are endless; it's a skill you can use for the rest of your life, and one that's going to become even more valuable as time goes on.

In order for you to keep this book nice and clean so you can continue practicing, I recommend using transparent paper (see suggestions on page 11) as an overlay on the guidelines as you go through the book. You can also photocopy the pages or guidelines if you prefer

to write directly on a piece of copy paper. I promise to be your guide along the way with suggestions and helpful tips.

Your Calligraphy Teacher

Who am I, anyway? I'm an artist named Virginia. Nice to meet you. Years ago, I met a pointed pen calligrapher, and after seeing her incredible skill, I became so enamored and intrigued that I decided, "Hey, I'm going to teach myself calligraphy!" Easy enough, right?

At the time, there was a very limited amount of resources available for anyone wanting to learn calligraphy. I went to a local art shop and bought expensive paper, a large supply of ink, and what I thought were the best tools. I came home, cleared off my kitchen counter, and sat down, certain I was about to create a masterpiece.

Despite my confidence, it quickly became obvious that I had no idea what I was doing. I went through notepad after notepad trying to make my lettering look pretty. Instead, it looked a lot like this:

And, on a good day, maybe more like this:

For months, I struggled to figure out what I was doing wrong. I found a few calligraphy videos and was determined to make my attempts look as smooth and effortless as theirs, but became so frustrated that I desperately wanted to quit.

I knew quitting would be the easier option, but my stubbornness prevailed and I was determined to keep trying. So I did.

I ended up taking an online class and eventually, I attended several in-person workshops, classes, and conferences that taught me what to do. The more I practiced, the better my calligraphy looked. And all that time when I struggled by myself trying to figure out why there was more ink on my hand than on the paper? That's what taught me what not to do, which has proven to be a valuable lesson that's helped me teach others, kids and adults alike.

Looking back, I was using all the wrong supplies, didn't know the first thing about caring for my tools, and didn't understand things like the huge impact of angles. This book is where I will share my knowledge and experience with you. I'll chime in with extra troubleshooting tips along the way, and I hope I can convince you to stick with it. With enough patience and practice, you can learn whatever you put your mind to! Also, for the record, anything an adult can do, a kid can do better. Don't forget that.

So, what are we waiting for? Let's dive in!

Calligraphy Terms

I'm going to use some words in this book that you may not recognize. It's important to learn these words so you can communicate about calligraphy and fully understand what's what. I'm going to split these words up into categories to make it easier to find them later, and as you're going through the book, feel free to flip back to this section if you need a refresher. Other calligraphers use different words to describe things, so I'll include some of those here as well.

The Tools

nib: The tiny metal piece that goes into the end of your pen holder and transfers ink to the paper. In pointed pen calligraphy, we use flexible pointed nibs, and the tines separate when you apply pressure.

Here is a diagram to show you the parts of the nib and other terms that are helpful to know:

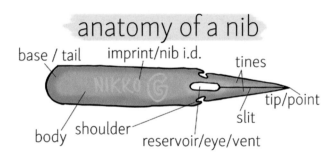

anatomy of a nib

base / tail imprint/nib i.d. tines

NIKKO

body shoulder reservoir/eye/vent tip/point slit

As you can see, some calligraphers have different names for the parts of the nib. For example, some call the hole in the nib its reservoir, while others refer to it as the eye and others call it the vent. Want to know another funny term I sometimes use? The whale hole! Doesn't it kind of look like a whale's breather hole?

tine: A sharp pointed prong. A nib has two equal tines that sit alongside each other in a resting position and separate when you apply pressure.

pen holder: The actual pen piece, also called a nib holder or a dip pen.

flange: The part of the pen holder that holds the nib.

scratch sheet: A piece of scrap paper on which you can scratch or dab excess ink off your nib after you dip your nib into the ink. I like to use a large Post-it Note as my scratch sheet.

guard sheet: When working on a final piece, this is a piece of scrap paper you put between your writing hand and the paper you're writing on to protect the main piece.

The Guidelines

Guidelines are the lines that help you keep your lettering straight, consistent, and properly sized. As you become more comfortable with your calligraphy skills, you can certainly go without them and break the rules (something I encourage!), but it's best to learn the basics by always writing either directly on guidelines or on a piece of transparent paper placed on top of guidelines.

ascender: In minuscule letters, this is the letter's upper section that extends above the waistline, like the top of a *b*.

descender: In minuscule letters, this is the letter's lower section that extends below the baseline, like the bottom section of a *y*. It is sometimes referred to as the tail.

x-height: The height of the lowercase letters such as *n*, *c*, or *e*, but not the letters with ascenders, like *d* or *b*.

baseline: The guideline that marks the bottom of all letters that don't have a descender.

waistline: The guideline that marks the top of the x-height space.

ascender line: The guideline that marks the top of the ascenders.

descender line: The guideline that marks the bottom of the descenders.

slant: The amount a letter leans or tilts from an imaginary vertical line.

slant line: The line that indicates the degree of slant desired.

The Strokes

A stroke is a mark or line created by your nib. Here are a few other important words and phrases to know when describing them.

hairline: A thin line created by the point of your nib; the thin part of a letter.

shade: A thick line of ink created when you apply pressure to your nib; also called a swell of ink.

entrance stroke: The stroke that begins the letter.

exit stroke: The stroke that ends the letter.

flourish: A decorative element you can add to your lettering, either around the letters or directly connected to the letters. Some might call them loops, loop-de-loops, curlicues, or swirls.

The Letterforms

counter: the enclosed empty space inside of the letter.

oval: a thinner circle and a common shape you see in calligraphy letterforms.

majuscule: an uppercase letter, also known as a capital letter.

minuscule: a lowercase letter.

Here is a diagram to show you some of these terms:

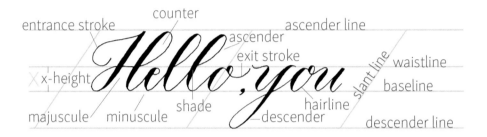

As you can see, I typically draw the ascenders to be slightly shorter than the tops of the majuscules to make the capital letters more pronounced.

Essential Tools

pencil: Any pencil you have will do. You can use a wooden pencil or any type of mechanical pencil if you don't want to deal with a sharpener. If you're curious, my favorite pencils in the world are made by Blackwing. Their lead is very smooth and it doesn't smudge, and since they have a square eraser tip, they don't accidentally roll right over wet ink when you're working on something. Blackwing also makes a nifty pencil-sharpening tool with two separate sharpeners, one for the wood and one for the graphite core, to make nice, long points. But like I said, no need to get fancy; any ol' pencil (and sharpener) will work!

eraser: You'll need a good eraser. And by good, I mean big. I rarely use the erasers that are actually attached to pencils because they're too small. (Yes, that means I make a lot of mistakes!) I prefer kneaded erasers, as they don't leave behind any residue when you use them. Plus, they're fun to squeeze. I also really like white erasers in either block or

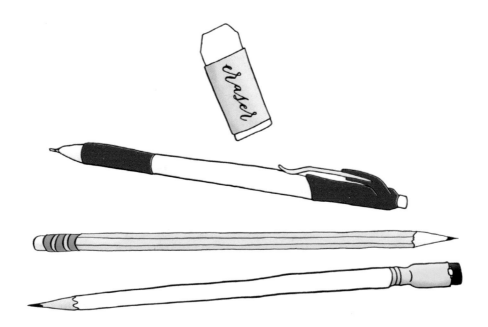

mechanical stick form, and I always carry around a tiny sand eraser by Tombow for any "calligraphy emergencies." Sand erasers are rougher than normal erasers, and they can scratch off ink if you need to fix something on a final piece.

paper towels: You will need to have a few paper towels handy when you're doing pointed pen or brush pen calligraphy, as you'll use them to clean your tools. Viva makes my favorite paper towels, because they're more cloth-like and don't snag as easily, but any paper towels will work well.

oblique pen holder: The pen holder I recommend for all beginners is called a Speedball Oblique Pen Nib Holder. It's black, plastic, and has a funny shape to it, which allows you to write by holding the pen a little bit in front of your hand and on an angle. It takes some getting used to, but I truly believe it's the best pen holder with which to learn. Later on (page 25), I'll teach you the best way for holding the oblique pen, depending on if you're right or left-handed. However, there's an alternative pen if, for whatever reason, you don't like the oblique style or you prefer to write more vertically: a Speedball Standard Pen Nib Holder. Many calligraphers, once they feel more advanced in their calligraphy skills, choose to invest in pen holders that are made of other materials (such as wood or acrylic) and have metal flanges (the piece that holds the nib). Etsy is a great source for finding these styles!

nibs: I recommend getting at least two Nikko G nibs to start. Zebra G nibs are a similar alternative; they're a little bit sharper and slightly more flexible than the Nikko, so you can achieve thinner hairlines and thicker shades. Once you learn the basics using either the Nikko or Zebra G nibs, I encourage you to try out some of the other nibs available to see if you have any personal favorites. There are a lot of different types, and some feel better to use depending on how much pressure you typically apply to your pen, or whether you're working with smooth or fibrous paper textures. Some nibs are also better to use if you're planning on writing big or small.

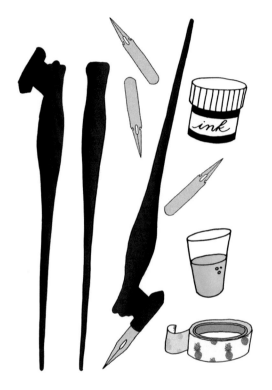

black ink: My favorite black ink is Moon Palace Sumi Ink. It dries with a beautiful sheen and is waterproof. This is the ink I recommend for learning and practicing pointed pen calligraphy.

jumbo dinky dip with a screw-top lid: Is that not a fun name for an art tool, or what? A dinky dip is the holder for your ink, also known as an inkwell. Inkwells come in all shapes, sizes, and materials, but I recommend starting out with a plastic dinky dip with a screw-top lid. (You're less likely to spill with a screw-top than a snap-top!) Although any size is great, I prefer the jumbo dinky dip because it holds more ink and you won't have to refill your ink as often. The plastic vials of the dinky dips typically fit into a wooden square or rectangle, which keeps them from tipping over. It's important to remember that the wooden base will start off all nice and clean, but it will quickly be covered in accidental ink splatters. This is normal, and the more ink splatters your wooden base has, the cooler you are.

glass cleaner: Commonly known as Windex, this is what you'll use to prime the nib. More on that on page 27!

water: For the purposes of learning the basics, tap water will work splendidly. However, the best water to use for cleaning your tools and diluting inks and paints is distilled water,

especially if you live in a place where your tap water has more chemicals and is considered "hard." Distilled water is water that doesn't have those impurities.

two short, small cups: You'll need two short, small cups—one to hold water, and one to hold glass cleaner. The sturdier the cups or vials, the better, as they're less likely to tip over. You don't want these to be too tall, because you'll want to be able to easily dip the tip of your nib inside. You can always use extra dinky dips!

brush pen: You know those Crayola broad line markers you probably have in a bin somewhere? I'm going to show you how to use those to make brush calligraphy (page 74)! Other brush markers I recommend are by Pentel and Tombow.

tracing paper: Tracing paper is translucent (see-through) paper that allows you to see and trace guidelines and letters from a piece of paper underneath. Tracing paper comes in either pads or rolls from which you can easily tear the size you want, and it is amazing for practice. I have used and loved a variety of tracing paper brands.

smooth paper: You'll quickly notice that writing with a pointed nib feels the best on smooth paper, because the tips of the tines are less likely to snag on the paper fibers. I recommend steering clear of textured, fibrous papers when it comes to learning and

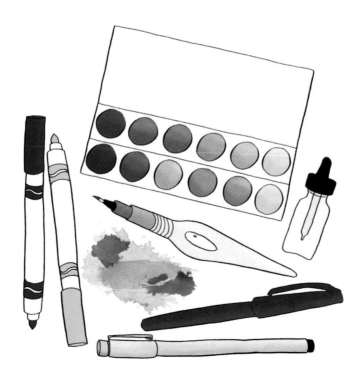

practicing calligraphy. Rhodia makes my favorite pads of paper, which come with blank, lined, or grid-lined sheets. The blank paper is semi-transparent and can also be used as tracing paper, especially when used with a light source. Canson Marker Paper and Borden & Riley Paris Paper are also wonderfully smooth papers to try.

scrap pieces of paper: You'll need a couple scrap pieces of paper to use as your scratch sheet and your guard sheet.

Other Helpful Tools

watercolor brush: If you want to get extra fancy with your brush calligraphy, you can use a watercolor brush. The ones I prefer are called Aquash Water Brushes; they store the water inside the pen so you don't have to dip into a separate container. However, you can use any type of paintbrush you wish, preferably one with a round tip.

watercolor: Watercolor comes in either pods or tubes, and is made by plenty of great brands.

watercolor paper: I prefer cold press watercolor paper because it has more texture than hot press.

white ink: My favorite brand of white ink is Dr. Ph. Martin's Bleedproof White. I'll teach you the best way to dilute it on page 79.

white pencil: When working with dark paper, Fons & Porter's mechanical pencil with white lead makes it so much easier to write guidelines or sketch out what you're going to write or draw.

gouache: A hard word to remember how to spell, but certainly a fun one to say: It's pronounced *gwash*! Gouache is an opaque (not see-through) watercolor, meaning the color is more pigmented. Mixed with water (and sometimes gum arabic) gouache gives you the ability to make custom shades of ink.

gum arabic: Gum arabic comes in either powder, crystal, or liquid format, and is a natural gum from the sap of acacia trees. In calligraphy, a little gum arabic can be added to your ink or gouache to achieve a few things. It can thicken the pigment and add shine, as well as prevent feathering and smearing. I typically either use Winsor & Newton liquid gum arabic or Jacquard powdered gum arabic.

gold ink: I prefer the Finetec M600 Artist Mica Watercolor Paint in Metallic and Gold for gold ink. The palette looks like watercolor pods; you apply water with a paintbrush and paint it onto your nib before writing. An alternative that I recommend is Pearl Ex Powdered Pigment by Jacquard. It comes in a wide range of beautiful metallic shades that you mix with water and gum arabic.

eyedropper or pipette: An eyedropper or pipette is a plastic or glass tube with a plastic bulb at the top that acts as a suction device. If you stick an eyedropper or pipette into a jar of water and squeeze the bulb, water fills inside the tube and holds. If you squeeze again, the water falls out. This allows you to transfer water to ink or ink into a new container.

construction paper: Construction paper is a great surface for making homemade cards!

washi tape: This is a type of adhesive tape that can be easily removed and adjusted. Washi tape is very helpful for sticking paper in place (for example, sticking tracing paper on top of guidelines) so the paper doesn't shift while you're writing, or for creating straight edges to reference if you're lettering on a final piece. You can also put a roll of washi tape around your container of ink to prevent it from tipping over. The best part of washi tape? All the fun patterns! MT is the original brand of washi tape and my absolute favorite. I also use washi tape to decorate cards and envelopes, and it's fun to write directly on washi tape if you want to create your own labels!

scissors: I don't know about you, but any time I try and do anything art or craft related, or if I'm opening new supplies, I always end up needing scissors. They're good to have handy, but don't be afraid to ask for an adult's help when using them.

paper clips: Instead of puncturing any holes into your work with a staple to hold pages together (whether it's practice sheets or final pieces), use paper clips. I prefer the ones that come in fun shapes and sizes! Also, if you're out somewhere and you need to mix your ink and you don't have a good stirrer handy, unbend one of your paper clips and use it to stir!

ruler: If you don't have your guidelines with you, but you want to write something, pull out a ruler and make some simple guidelines of your own with a pencil.

envelope guide: There are a couple tools out there that can help you make quick guidelines for envelopes, and I'll show you my go-to tricks later on in the book on page 93. Two tools you can use are a Lettermate, which is a stencil to help you quickly write guidelines for an address, or a Slider Writer, which uses a laser to provide straight lines.

light box: A light box is an electric box that is brightly illuminated across a flat surface, making it easier to trace anything that you place on top.

pliers: Sometimes your nib can get stuck inside your pen holder, especially if the ink hasn't been cleaned off properly. (Tip: Try twisting!) It's good to have a set of pliers on hand if nothing else seems to work. I'd ask an adult for help.

You may be asking yourself, where can I find these things? First, try using what you already have at home, although I highly recommend using at least the black ink, nibs, and pen holder I've listed in this section. You might be able to find some of these things in your local art store, but shopping online is a safe bet. Here are three places where I purchase everything:

Amazon: amazon.com

John Neal Bookseller: johnneallbooks.com

Paper & Ink Arts: paperinkarts.com

Modern Calligraphy

There are many different styles of calligraphy, such as Spencerian, Roman, Gothic, round hand, italic, uncial, engrosser's, and copperplate. In this book, we're going to be focusing on modern calligraphy, which is a form of calligraphy derived from traditional styles, but with added flexibility, friendliness, and flair.

If you've tried calligraphy before, you might have encountered a lot of rules when it comes to your lettering. People might have criticized your letters, saying, "They need to be exactly like this. This is too small, too big, too slanted, too short, too long, too rounded, too square, too this, too that."

If you ask me, too many rules can spoil the fun! However, learning the main rules about the basic techniques of calligraphy is important for improving your skill in the long run. As Pablo Picasso famously said, "Learn the rules like a pro so you can break them like an artist."

Throughout most of this book, we'll be using the oblique calligraphy pen holder. As I mentioned in Chapter 2, this is the best style of pen to learn with. Later on, we'll talk about when it makes sense to write with a straight pen and when to use a brush pen.

Workspace

Before we dive into learning pointed pen calligraphy, let's evaluate your workspace. You want to sit with both of your feet flat on the floor, facing a flat surface. That's your first important calligraphy challenge: Repeat, "feet flat on the floor, facing a flat surface" three times as fast as you can.

Just kidding!

Do you have enough space on either side of you? Here's an easy test to find out: If you can't flap your arms like a chicken without hitting something or someone next to you, make more room.

Here are a few other things to consider: Is your table too high? Can your elbows rest nicely on the table? How is your posture? What are your legs and feet doing? Do you have enough light?

For reference, don't wobble in your chair to try and comfortably reach a high table, hunch forward like a turtle, or sit in the dark.

Wrong ways to sit!

Instead, do this! Ta-da!

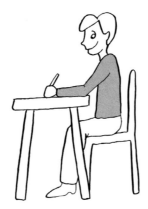

Make sure you're also working in a space where it's okay if you accidentally spill your ink. Mistakes happen. It might be a good idea to put some newspaper on the table or on the floor underneath where you're sitting, especially if there's a rug. Calligraphy ink can stain fabric, and we wouldn't want that.

Warm-Ups

We're going to start by warming up our arms and shoulders. In order for our hands and fingers to work properly, the rest of our upper body needs to be loose.

First, raise your hands in the air and shake them loose. Go on and flail them around and get out all your wiggles. Now, interlock your fingers and turn your palms to the ceiling. Push your hands upward and hold for 10 seconds. Next, bring your arms down and roll your shoulders backward slowly five times. Then roll them forward slowly five times. Move your shoulders back and down and tilt your head to the left and right a couple times.

Put your writing arm straight out in front of you. Pull your fingers back as far as they can go toward your arm and feel that stretch. Now, push your fingers in the opposite direction, toward your underarm, so they're almost touching your wrist. Next, make a fist and roll your hand in one direction five times, then switch and roll it in the opposite direction five times. While you're doing that, knead your forearm with your opposite hand. Anytime you're taking a break or you feel a little stiff from practicing your calligraphy, redo all of these warm-up exercises.

The best way to warm up your fingers is to pretend you have an imaginary piano in front of you and you are a famous pianist playing a dazzling finale at a concert. Play for a while. Ready? Go! Gosh, what an awesome song that was!

Take a piece of scrap paper and place it in front of you. If you're right-handed, tilt your paper like this:

And if you're left-handed, tilt your paper like this:

It's okay to tilt your paper as far as you need for it to feel comfortable. It's actually common for calligraphers to spin their paper in all sorts of directions to get their angle accurate for what they want to accomplish, so don't be afraid to adjust this.

Now, grab your pencil. Make sure you hold your pencil close to the base using only your thumb, index finger, and middle finger. The pencil should rest on your middle finger, held there by your thumb. Your index finger (also known as your pointer finger) should rest lightly on top to guide the pencil.

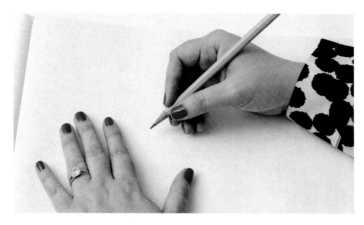

Now, let's draw some ovals.

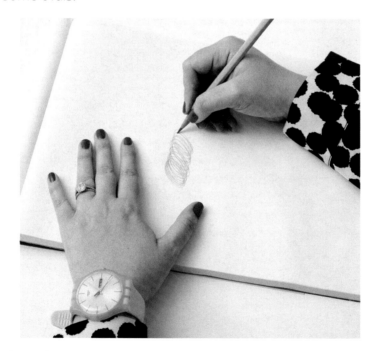

When you're making the ovals, try to slowwwly move your hand to the right, keeping the same motion as you create a chain of ovals that are more or less the same size. Your hand should be gliding across the paper.

Extra help: If you're struggling to easily move your hand across the paper at any point in the book, here's a fun secret that will help! Find a deck of cards, pick a card, and place it underneath the palm of your hand. (Does this sound like a magic trick? Well, it sort of is.) As you're writing, your hand will feel more slippery on the paper and you will glide with ease. Try it sometime.

Make sure you're keeping your fingers and wrist still, and only moving your arm. This is called whole-arm movement, where the motion is created by your shoulder. You should be holding the pencil like so, keeping a loose grip.

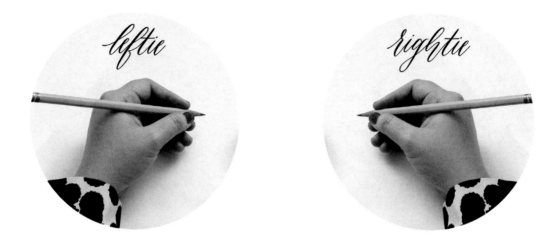

Let's open up that arm even more and make those ovals bigger.

Want to try some figure 8s?

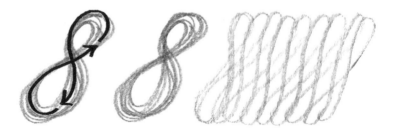

Continue that same technique of moving your hand slowwwly to the right.

Try writing your name the same way, where all you move is your arm. Take note of how loose your hand is on the pencil. This is how you'll want to hold your calligraphy pen.

Setting Up Your Pen

Now that you have your workspace all set up, and you've warmed up your arms and hands, it's time to get to know your nibs. Remember this nifty diagram from earlier?

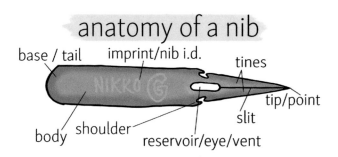

The nib is what holds the ink. The sharp tip of the nib draws a delicate line. The nib is flexible so that when you apply pressure, the tines of the nib separate and create a thicker line, or swell of ink. The nib is the most fragile part of the pen, so you want to treat it with lots of love. I'll talk more about how to care for your supplies on page 49, but keep in mind that you'll want to find a safe place for them.

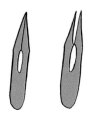

To get started, you'll want to use an oblique calligraphy pen holder. The oblique style is the one with the funny-looking elbow piece. I know it looks a little scarier than the straight pen holder, but I assure you it's the best pen on which to learn, and it will really help you achieve your best angles. However, if you try the oblique style and hate it, give the straight pen holder a try. It's all a personal preference, and no one way is the right way.

First, place the nib inside the calligraphy pen. Where, exactly? You'll see a tiny, carved-out circle at the end of the pen holder—put the nib in there. You'll want the whale hole and the imprint of the nib to face upward. One of the easiest and most common mistakes is not having the nib in the right position, so let's be sure we've got that covered.

Two of these nib positions are right, two are wrong. Can you guess which ones are correct?

Take a closer look...

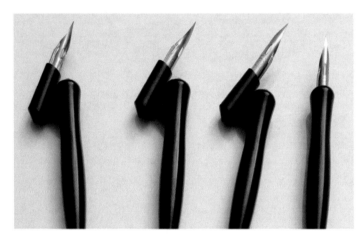

The first nib is upside down, and appears inverted and concave. (There is actually a scenario where this position would work, which I'll get to on page 26.) The second one is facing to the side. The last two are facing upward, which is correct!

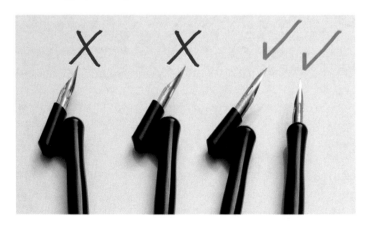

Fun and Friendly Calligraphy for Kids

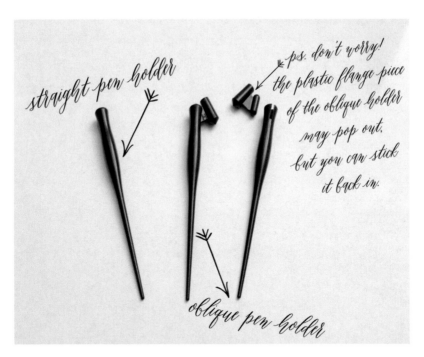

straight pen holder

ps. don't worry! the plastic flange piece of the oblique holder may pop out, but you can stick it back in.

oblique pen holder

Make sure your nib feels secure and snug inside the pen holder. It's okay to push a little hard.

> **Extra help:** If you ever have trouble removing the nib, try twisting it. And if that doesn't work, ask for help from an adult. Suggest pliers, if needed.

If you're right-handed, this is how you'll want to hold the pen. Take note of how the nib looks in relation to the pen holder. See how my thumb is right up against the flange? Holding it close to the base like this will give you the most control.

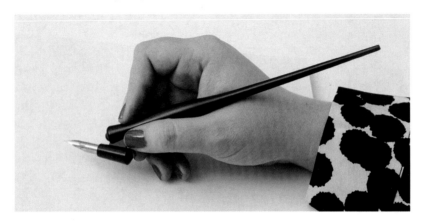

If you're left-handed, you have a couple options. You can either hold your pen with your thumb underneath, supported by your pointer, middle, and ring fingers on top, keeping the nib in the same exact position as it is for the righties. When holding it like this, you're writing from underneath the line of text and moving your hand underneath the letters, which helps you avoid smearing the ink.

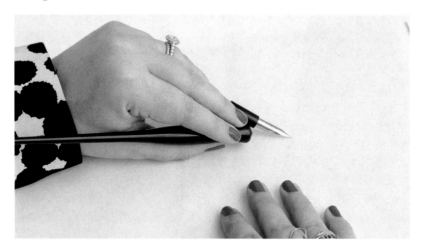

Another option is something called curling, where you're going to break the rule of the nib position. To do this, turn the pen holder over so the nib is upside down, making sure the flange is on the right side of the pen holder. This is like the example I mentioned earlier where you basically put the nib in the holder the typical way, and then turn the whole thing upside down. You'll have to be careful you don't smear the ink with the palm of your hand, but this may feel more comfortable to you.

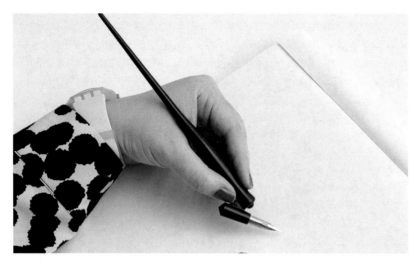

Fun and Friendly Calligraphy for Kids

I know it can seem like this is all trickier for lefties, but please know that some of the greatest calligraphers—and artists!—are left-handed, so don't let that ever scare you.

> **Extra help:** Are you a lefty? Check out some helpful resources at iampeth.com.

How should you hold a straight pen holder, you might wonder? Just like you held the pencil earlier.

> **Did you know:** Your hand has something called muscle memory that remembers how you learned to write letters of the alphabet. It's the reason you can write without really thinking about it. You may find yourself wanting to hold the pencil a different way based on how you typically hold it, but let's pretend you're learning how to write for the very first time. The great thing about muscle memory is you can teach your hand new ways of writing and drawing with enough practice.

I want you to remember this important rule about calligraphy: In calligraphy, you draw the letters instead of write them. And in order to do so, you need to make sure your hands and utensils are angled to the paper correctly, and that you aren't holding them too tightly, or in a way that will cause your hands to cramp.

Priming Your Nibs

Alright, you soon-to-be calligraphers, it's time for a super-important step that I wish I knew when I was starting out.

Nibs have a chemical coating on them when they come from the store that acts as a preservative. If we were to dip this nib right into the ink, the ink would bubble and slide off because the coating wouldn't allow it to stick to the nib correctly. Therefore, we must prime the nibs first by cleaning off that coating.

Pour some Windex (or any other type of glass cleaner) into a sturdy holder, dip your nib inside for a few seconds, and then rub the nib with a paper towel. Dip the primed nib into ink high enough for it to go into the whale hole.

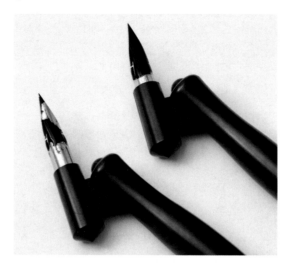

The one on the left wasn't primed before I dipped into the ink, but the one on the right was. See the difference? Priming the nib will help your ink adhere to the nib and write on the paper much more smoothly.

> **Extra help:** As seen here, dip your nib far enough into the ink, but not too far where it gets up inside the pen holder.

Keep in mind that once you prime a nib, you don't have to do it again until you reach for a fresh nib from your batch. You can continue using glass cleaner any time you need to clean off your nib, but I usually just use water.

Making Marks

To start writing, pour some black ink into your dinky dip or inkwell and be very careful that you don't spill. It's okay if you need to ask for help with this step.

On a new blank sheet of smooth paper, create some simple strokes. I don't suggest writing directly in the book, as you'll want to come back and be able to practice. You can write with this book next to your practice paper as a reference, trace over my strokes with translucent paper, or copy this page or one of the practice guidelines (page 83) to write directly on them.

Based on what hand you use to write, angle your paper accordingly. If you're left-handed, tilt your paper to the right. If you're right-handed, tilt your paper to the left. You can continue to adjust the angle as you go until you find the perfect paper position for your hand.

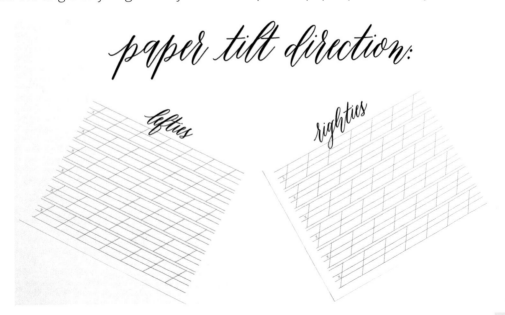

paper tilt direction:

lefties *righties*

You'll want to have another piece of scrap paper nearby that can act as a scratch sheet. When you dip your nib into the ink, it's helpful to tap the side of the holder with the point of the nib so any excess ink falls off, but sometimes you still need to make sure the ink is running smoothly by drawing a few lines on your scratch sheet. Make sure your scratch sheet is positioned somewhere in your workspace where your hand and arm isn't going to accidentally smear it. It's okay if your scratch sheet looks totally messy at the end, but you don't want your clothes or hands to be covered in ink.

First off, just press the tip of the nib slightly to make a few tick marks. You can do these tick marks on your scratch sheet or directly within the x-height of the guidelines.

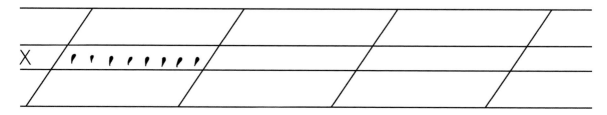

Now, let's draw some delicate, hairline strokes. Start at the baseline and push up to the waistline. You're only using the very tip of the nib. This is called an upstroke.

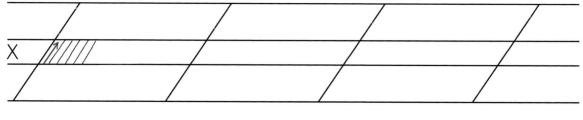

Now, try and pull the line down. Apply pressure and the tines will separate and create a thick shade of ink. This is called a downstroke. If your lines aren't very thick, apply more weight with your hand.

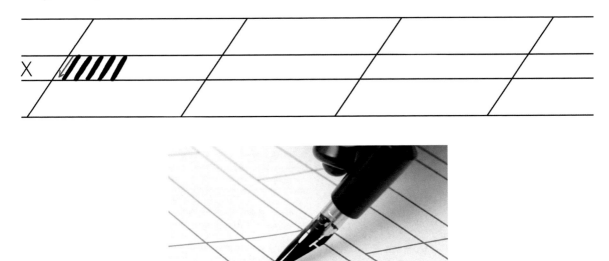

Do you see how the tines separate when you apply pressure and pull?

Calligraphy is a combination of that push and pull, and its beauty is a result of the combination of those thin and thick lines.

Here is something to keep in mind: Hairlines can be created in any direction, but all upstrokes must be hairlines. Shades, or swells of ink, can only be created on downstrokes.

To make sure that's clear, let me put it a different way. You can draw the thin lines in any direction with the tip of your nib, by pushing up or by pulling down, as long as you're not applying pressure. But all upstrokes have to be thin because the tines can't separate when you're pushing upward. Similarly, you can only create shades on the downstrokes. Therefore, depending on what you're trying to write or draw, it helps to turn your paper if you want shades of ink to be going in different directions.

Let's try this exercise now. You're going to start at the ascender line and pull down with no pressure so you're just creating a hairline. When you get closer to the waistline, apply pressure so the tines separate and the ink line becomes thicker. As you approach the baseline, release the pressure. Figuring out the right pressure adjustments is key when learning calligraphy, and you'll master it with enough practice.

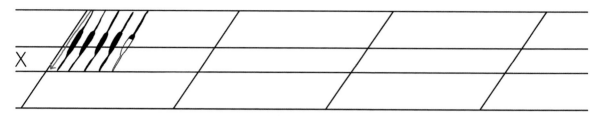

I ran out of ink on that last one, but left it for you to see what it might look like.

Time for the rollercoaster! Try going up and down, up and down, in the wave design like below. You'll start at the baseline and push up to the waistline before rounding out at the top and pulling back down to the baseline.

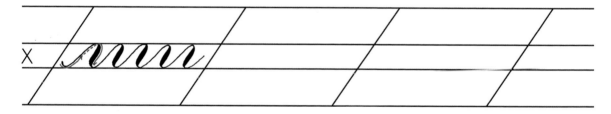

Let's try some ovals. Draw them in the counter-clockwise direction of the arrow. Remember that we're working with ovals, not circles. You can't put a circle on an angle, but you can adjust the angle or the tilt of an oval. You'll see this shape a lot in the letterforms.

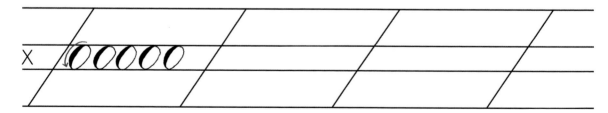

Use the same counter-clockwise direction for the big ovals.

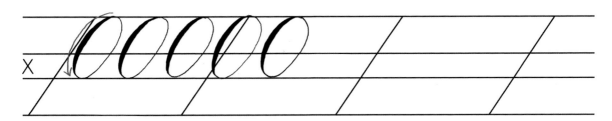

A similar shape to the oval is a swirl, and you draw it kind of like how you would make the number 6.

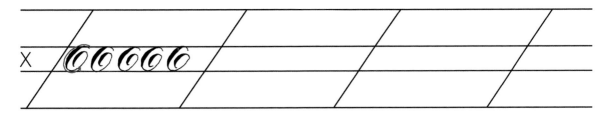

Another common shape you're going to use a lot is called a compound curve. It has a slight S-curve to it. First try starting it at the waistline, and then the ascender line.

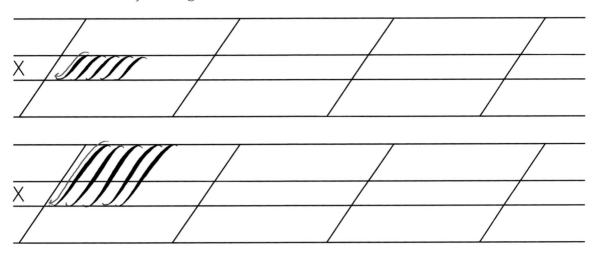

Flip to page 83 if you want a full page of guidelines to trace for more practice!

Common Problems

Anyone having trouble and feeling frustrated and like you want to sling your pen across the room? Well, don't. Let's figure out what may be the problem.

Are your shades looking a little more like this?

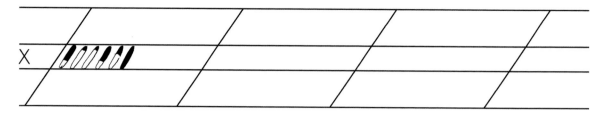

First of all, don't fret: This is totally normal. Some people call this railroading, which happens when the tines create two hairlines rather than a singular swell of ink. It looks like railroad tracks or marks made by skis, lines that run parallel to one another. If you were using a custom mix of ink, I'd suggest diluting it a bit more. But with the black ink, it's probably because you're not dipping your nib far enough into the ink. Even if you're doing everything correctly, however, this will still happen from time to time and you can re-dip, fill in where you left off, and keep going.

Are you splattering ink all over the place? Your nib is probably angled incorrectly. If the tines can't separate evenly, they're going to twist and spray the ink when you apply pressure. Think of the tines of the nib as two fingers that need to separate to evenly distribute the ink on the paper. If only one tine is touching the paper, the ink can't make a thicker stroke if you press down.

Does the ink feel like it's just sort of falling off the nib into a blob? You're either loading too much ink on your nib (don't forget to try a few marks on your scratch sheet to get off excess ink!) or you might be holding your pen too vertically.

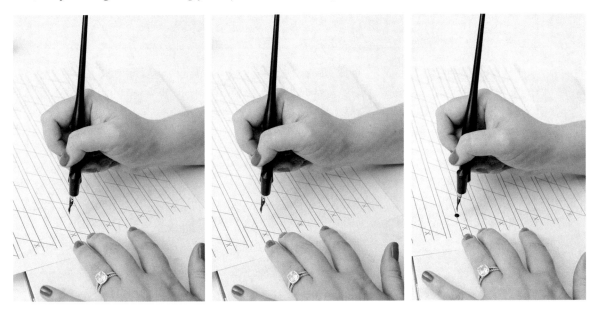

Try making your pen holder and nib more parallel to the paper and adjusting that angle to see what works the best. Angles are slightly different for everyone based on their posture, hand position, how close they are to the paper, the tilt of their paper, and the exact way they hold and use the pen.

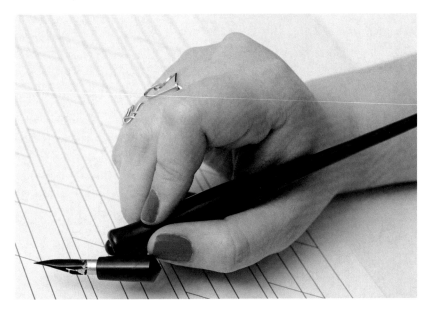

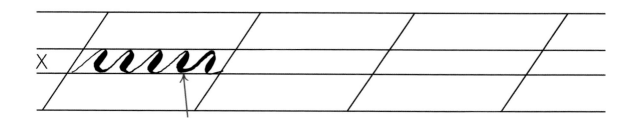

Does yours look more like this? If the ink is collecting at the bottom and dragging into your upstroke hairline, it's because you're not releasing the pressure early enough on your downstroke. Try and imagine the tines of the nib on a one-second delay from when you release the pressure. They need a chance to catch up, so release pressure slightly earlier than you think you need to.

> **Extra help:** How often should you re-dip your nib into the ink? The more you practice your calligraphy, the more you'll be able to feel when it's time to re-dip. It all depends on factors like the size of your letters and the absorbency of the paper; you may be able to write a few words, or only a letter or two. If the ink runs out mid-letter or word, re-dip and then start filling in the space where you left off.

Slant Lines

Before we dive into the minuscule alphabet, I want to briefly chat about the slant line. The slant lines in this book are all positioned on a 55-degree angle. I want you to know that you can later switch up the angle of your letters however you wish. Some calligraphers choose to write on more of a slant, while others like their letters upright and vertical.

For the warm-up exercises, the slant lines were black. For learning the alphabet, you'll notice that they are gray. I want you to still be able to see them if you're tracing the pages, but I know they can sometimes be distracting when you're drawing the letters. I'm also going to thicken the baseline a little bit, just so it's easier to see where your letters should rest.

As a reminder, the best way to use these guidelines is to either trace over them with tracing paper or thin paper, or you can photocopy them and write directly onto the copy paper.

Fun and Friendly Calligraphy for Kids

You don't want to write directly in the book because then you won't be able to continue practicing.

Okay, great! Now that your pen is all prepped and you've done your warm-ups, you're ready to learn your letterforms! Get ready to turn the page and jump into your calligraphy journey!

Chapter 4

Learning Letterforms

To learn to write the alphabet, we're going to go in a special order based on the shapes of the letters. Think about calligraphy as simply drawing and combining different shapes to form the letters. Try and write each letter a few times. I'll give you a couple variations on some letters to try too! If you need more room to keep working on a letter, more blank guidelines are on page 83.

Oval Letters

When you draw these letters, follow the direction of the red arrow. The head of the arrow is the end of the stroke, so start where there isn't a point. You'll notice that for the letters with multiple steps, I've included how it would look if you separate the different steps before showing the complete letter so you can really see the shapes at work.

X *GCGC*

You'll draw the *c* as you would if you were drawing half of an oval. Start by placing the tip of your nib fairly close to the waistline and begin making a hairline stroke. Draw your line counter-clockwise and start applying pressure after the top curve. Release that pressure before you get to the baseline, and keep your hand steady as you come back up.

Remember to move more slowly than you would if you were writing with a ballpoint pen. You don't want the start and end of the *c* to be too close together, or it will read like an *e*. If you'd like, you can try a small loop **entrance stroke**, which is a fun alternative, especially if it's the first letter of the word. The entrance stroke is where you start drawing the letter. It's the line or mark of the pen that introduces the rest of the letter, and it can be on any part of the letter that makes the most sense to form the shape you need.

X *OOOO*

You've already drawn the letter *o* in warm-ups—it's just an oval! Pretend it's a clock and start the *o* at about the noon or one o'clock position. Go in a counter-clockwise direction and apply pressure as you draw the downstroke, until you get to about 8 o'clock. Finish the oval with a hairline that connects to the start of the letter back up at the waistline. Try creating a loop **exit stroke**, which is a great way to connect it to the next letter in a word. The exit stroke is where you finish the letter or word. It's the line or mark of the pen that ends the shape you're drawing, and it's typically on the right-hand side of the letter, since we read from left to right.

X　*aαα*

This version of the letter *a* has two steps, so you're going to pick up your nib halfway through the letter. First draw the oval, then add the stem. For the stem, start at the waistline, applying pressure, and pull the stroke down to the baseline, releasing pressure before you get there. When you reach the baseline, curve back up slightly with a hairline exit stroke. I show you how it looks with those two steps separated, but make sure you write a version where those two steps connect.

X　*d d d d d d*

One version of the *d* is the exact same as the *a*, but with a taller ascender stem. You'll notice that I don't draw the ascenders all the way to the ascender line because I like my capital letters to be a little taller. You can decide how tall you'd like your ascenders to be, but I suggest getting pretty close to the ascender line.

The second version of the *d* requires two steps as well. Once you draw the oval, pick up your pen and touch down again on the waistline, right by the top right side of the oval, about where 1 o'clock would be on a clock. Push that hairline stroke out and up toward the ascender line, loop back to the left, then finish by pulling a thick downstroke toward the baseline. Release pressure right before you get to the baseline, make a small curve, and end by pushing up a small hairline exit stroke.

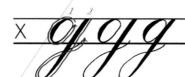
X　*g g g*

The *g* is almost like an upside-down *d*. First, make the oval. For the stem, start at the waistline, apply pressure, and pull the stroke down to the descender line, looping clockwise and crossing back over to the right. It's important that you keep that last part of the *g* as a hairline stroke, since it needs to cross over the shaded downstroke.

> **Extra help:** You can cross a hairline with a hairline, or a hairline with a shade, but you never want to cross a shade with a shade. That's just asking for an ink blob to happen.

The *q* is very similar to the g, except the downstroke of the stem loops counter-clockwise and out to the right. The stem comes back in and touches the base of the *q* right at the baseline. The exit stroke comes out from that same point on the baseline in a hairline stroke. For most words, it connects to the letter *u*. When you start putting the letters into words, you'll start looking ahead to see what letters come next, and that will help you decide how you should end the letters.

For the *e*, make that same *c* shape, but start your letter more inside the oval, lower than the waistline and closer to the left side of the letter. You can also make your *e* like you would in cursive, as a small loop, but I have to admit that sometimes this version reads like a small *l* rather than an *e*. Give it a try. Do you see what I mean?

When you're done filling out a piece of tracing paper, give the ink a little bit of time to dry. I know you might be looking at your first page of letters thinking you don't want to keep it, but

I promise you'll love looking back at your progress. To keep it nice and safe, place it flat in a safe, cool place to fully dry before you stack it with anything else. Otherwise, the ink might smudge or it might stick to another piece of paper.

Would you like a blank guideline sheet to put underneath your paper for more practice? Head to page 83.

Did you know: People have communicated by writing things down for thousands of years, ever since the Egyptians drew hieroglyphics. Arabic, Greek, Hebrew, and Russian alphabets are commonly used today, but they're completely different from the ABCs we use. Some cultures don't even use alphabets. For instance, Chinese writing uses pictures instead of letterforms. There are also other alphabets that are no longer in use and we can only see them in preserved manuscripts. Before the invention of the modern printing press in the mid-1400s, guess how books were created? Every single letter was written by hand. Gasp!

Ascenders and Descenders

I'm including three different ways to draw *b* so you can start thinking about ways you can adjust your letters. To make the first option, push your entrance stroke up and to the right, from the baseline to the waistline. Then, pick up your nib and move it close to the ascender line. Apply pressure and create one thick downstroke to be the spine of the letter. When you reach the baseline, push the stroke up and to the right so it approaches the waistline, then curve down in a clockwise downstroke. Release a small swell of ink, curve in toward where your stem met the baseline, and loop back out to the right.

I know this particular looped end stroke can seem confusing at first, so take a second to look at the shapes within the letters, which will make the task feel more familiar and doable. What number do you see in the belly of the *b*?

If you guessed 2, you're right! Let's try again. After the entrance stroke, create a thick downstroke from the ascender line. Without picking up your pen, push that line up to the waistline, and simply pretend you're writing the number 2 as you round out and come back down to the waistline.

If you leave too much room between that loop of the *b* (or the 2 shape!) and the bottom of the spine, it might look more like an h.

The second *b* option starts with the same entrance stroke from the baseline up to near the waistline. Pick up your nib slightly and move it a little to the right. Then, start an upward loop pushing up from the waistline in a counter clockwise direction, curving it back in for a long downstroke where you apply pressure until you get close to the baseline. Just like with the previous version, push the line up from the baseline to the waistline and finish the belly, or bulb, of the letter with the shape of a 2.

For the last *b* option, start by pushing your entrance stroke up toward the waistline. Pick up your nib and move it slightly to the right. Push up in a rounded counter-clockwise stroke toward the ascender line, curving into a downstroke and applying pressure as you near the baseline, but releasing that pressure before you actually hit the baseline. Round out the bottom of the letter as you would an oval. Curl back up toward the waistline, pushing with a hairline stroke and exiting the letter with a small, thin loop.

> **Extra help:** It can be easy to start off your letters nice and slow but then end quickly, and sometimes carelessly. The exit stroke is just as important as the entrance stroke and should be controlled and slow just like the rest of the letter.

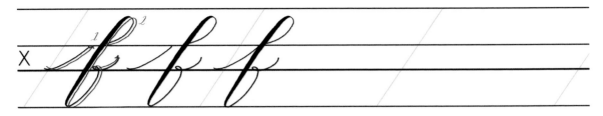

The *f* is going to remind you of the second version of the *b*. Create an entrance stroke that goes up and to the right, from the baseline to the waistline. Pick up your nib, move it slightly to the right, and then continue making an upstroke to the ascender line before rounding the stroke and creating a thick downstroke that crosses your second entrance stroke. Rather than stopping your thick downstroke at the baseline, continue on to the descender line. Round the stroke out to the right. Bring your line to meet the stem of the *f* at the baseline, then make a looped exit stroke to finish. Much like the ascenders, you can eventually figure out how long you want to make your descenders, which can really affect the look of your words.

> **Extra help:** Do you feel like your letters are still looking different from mine? One easy thing to adjust is the angle of your letters. As you're drawing the letters, make the stems parallel to the slant line and that will help the overall shape and look of your letters.

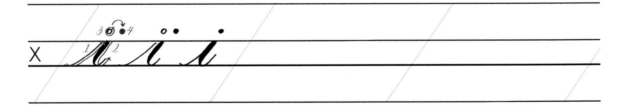

The *i* is pretty straightforward and since it's very similar to the *f*, which has a descender stem, we're going to sneak him into this section. You start by pushing the thin entrance stroke upward and to the right, ending the stroke at the waistline. Pick up you nib slightly, and pull the ink in a downstroke that traces over a bit of your entrance stroke and rounds out at the baseline so you can connect it to the next letter. When drawing the dot over the *i*, you can do a little flick of the pen, but I like to make mine nice and round. My trick? Draw

a tiny little circle the same width as your letter. Then, press the center of the circle with the tip of your nib and let the ink fill it in. Sometimes you have to press a couple times.

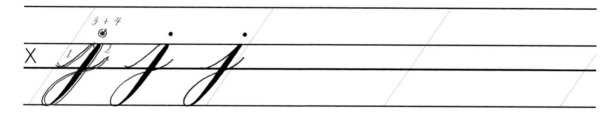

Make the j the same way as the i, but you're going to pull that downstroke of the descender from the waistline down to the descender line, then bring it back up so it rounds out to the left in a clockwise direction and crosses over to the right. We've seen this stem before; do you remember what letter?

The g!

Did you know: The dot over an i and j is called a tittle.

You're probably realizing the difference it makes if and when you pick up your nib when drawing the letterforms. Let's try the h. Push that same up-and-to-the-right entrance stroke, pick up your nib, and move it slightly to the right. Starting on the waistline, push the loop up toward the ascender line, rounding out at the top in a counter-clockwise direction and applying pressure as you come down to the baseline. Continue without picking up your pen as you push the hairline to the waistline, then curve down with a thick stroke. Pushing back up again to make a thin exit stroke. This last shape is like the rollercoaster warm-up we did on page 32.

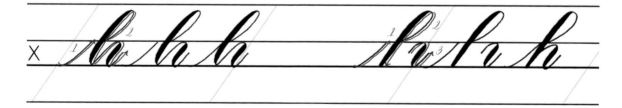

Let's try another version of the and this time, end your second stroke down at the baseline. Pick up your pen and do the third shape, the half of the rollercoaster, where you start in the middle of the x-height and push up to the waistline, pull down to the baseline with pressure, and push back up for the exit stroke. Do you see the difference between the two versions? There's a whole section of negative space in the first style that isn't there in the second one.

> **Did you know:** While the counter refers to the enclosed blank space inside the letters, negative space can refer to blank space around the letters and strokes. Something like the size of the counter or the amount of negative space can make such a big visual difference.

Let's try two different versions for the *k*. Start off with the same entrance stroke we've been using on the past few letters. Pick up your nib and make one long, thick downstroke, starting near the ascender line and ending at the baseline. Now, pick up your nib and make that second shape, the one that's unique to the *k*. It starts with a thin, left-leaning downstroke—even though you're pulling the stroke, don't apply much pressure—that touches the stem of the letter near the middle of the x-height space. It continues by going down and slightly to the right with a short, thick downstroke before touching the baseline and continuing up with a pushed, thin exit stroke. I like to think of this shape as one side of a butterfly's wings. Rather than creating a head of an arrow that points to the left, like we would with the print version of *k*, we are adding a little bit of flutter by curving the top and the bottom of that shape. Can you think of a way you could change this on your own? You could make that

second stroke look like it does in a cursive *ℓ*, or add a loop in the middle right where it touches the stem.

I'll show you one way to change it by just making the stem different. The difference in the second version is all about the entrance of the letter. Start your entrance stroke higher up, right above the waistline, and to the left of the rest of the letter. Curve down with a thin stroke that rounds up to the right. Instead of picking up your nib, keep going and push the stroke to the ascender line in a counter-clockwise direction before turning it into a thick downstroke that goes to the baseline, crossing over part of the entrance line. You could even apply this stem shape, that combines the entrance stroke to the stem, to other letters like the *b*.

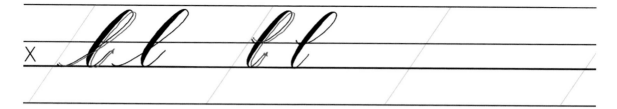

The *l* is fun because you can draw it in one continuous stroke. I included two versions for you so you can adjust the entrance stroke. You can start at either the baseline or the waistline, and then push the line up before looping around in a counter-clockwise direction. Make sure you either touch the ascender line or get pretty close to it. We wouldn't want your *l* to read like an *e*. Release pressure before you reach the baseline, and then curve up to the right with a pushed, thin hairline. Remember not to rush your exit stroke; it should be controlled like the rest of your letter.

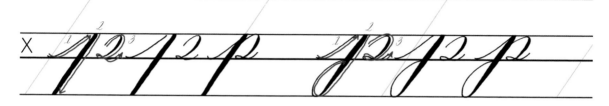

You'll start with an entrance stroke for the *p* and then pick up your nib to make a thick downstroke from the waistline down to the descender line. Before you start the second stroke, take a look at it. What does it look like to you? It's that same shape we saw with the *b*. I'll give you a hint: it's a number...

....it's a 2! Once you see the shapes in the letters, they seem a little more familiar and easy to draw, don't they?

The second version of the p is the same as the first, except the descender is a large loop. Start at the waistline and pull the downstroke, applying pressure. Before you reach the baseline, release the pressure and loop clockwise back up to the baseline. Finish by creating the bulb of the p by drawing the 2 shape. You could also combine the second and third steps of the letter by keeping the loop line going, crossing over the stem and drawing the 2 without picking up your nib. Remember to follow the red arrows to make the right strokes. If you're not a fan of that 2 shape, try writing it without the loop by curving the bulb of the p down to the baseline and in toward the stem, and simply tracing back over part of the curve with an exit stroke that heads back out toward the right.

Extra help: When you get to the bottom of whatever page you're working on, take a second to look at your writing arm. Is your elbow tucked back and off the table, and are you feeling a little cramped? It's easy for that to happen. Push that paper forward and away from yourself, giving your arm and hand more breathing room. Adjust your angles as you need to. Ahhhhhh. Feels better, doesn't it?

Before we continue drawing out letters, let's take a quick break to stretch and clean off our nibs.

Break Time: Clean Your Nibs

Let's take a small break and clean off those nibs. Not only is it important to get up and move around, but it's good to clean off your nibs every so often to make sure you're taking extra good care of your tools. Any time you're finished practicing, it's important to clean off all the ink from your nib and pen, clean up your work area, and store your supplies in a safe, dry place like a shelf or bin. Some calligraphers like to store their nibs in old Altoid containers. Ink can stain fabric if you're not careful, so it's also really important to make sure all of your caps are secure. If you get up and leave everything as is for hours or days on end, your tools aren't going to last very long, and you run the risk of something getting accidentally knocked over or ruined. Similarly, even if you pause and get up for 15 minutes, your ink could dry on the nib and be harder to scrub off, possibly shortening its lifespan.

Therefore, I like to clean off my nibs anytime I take small breaks to make sure I'm getting the most of out of them. Nibs won't last forever and will need to be replaced, and a new one will need to be primed.

How often should you replace your nib? A single nib can last for a fair amount of time, depending on how frequently you use it and how you take care of it. Nibs are relatively fragile and will tell you when they're ready to be replaced by showing you one or more of these signs. You know it's time to say sayonara to your nib if:

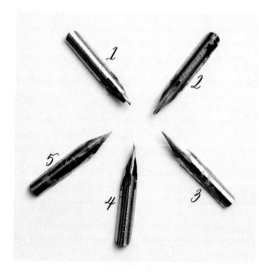

1. At least one of the tines is broken.

2. The tines are no longer connecting and there's a gap left between them even when you're not applying pressure.

3. There is residue goop left over from the ink and paper fibers that won't wash off.

4. The tines aren't sitting flush so one is raised higher than the other, or one tine is possibly twisted over the other one—which typically results in ink splattering everywhere.

5. The nib looks relatively normal, but the point of the nib feels dull, and you realize there's not as much difference between your hairlines and shades of ink.

Shapes, Crossbars, and Rollercoasters, Oh My!

Finished with your break? Let's start a new page of letters. If you need to warm up with any of the exercises on page 19, please do so.

Want to know my favorite letter? Meet *ℓ*. She's cute and different, which makes her extra special. You can write both of these versions without picking up your nib.

In the first version, push the line from the baseline slightly up past the waistline. Without picking up your nib, pull a small curved downstroke that traces over a tiny portion of your entrance stroke but leans slightly more to the right. You should be right at the waistline, or slightly underneath it. Then, pull the downstroke on the same angle as your slant line, rounding out when you get to the baseline and pushing your exit stroke up to about halfway inside your x-height.

Now, try the second version, which has a loop instead of the curve at the top. You're going to push that entrance stroke up slightly past the waistline. Instead of tracing back over your entrance stroke and creating a point, you're going to create a small loop in a counter-clockwise direction, ending the loop at the waistline or right beneath the waistline. Continue with a thick downstroke before releasing pressure and rounding out at the baseline, ending with a pushed upstroke hairline that finishes about halfway up in your x-height space.

You can make the *ℓ* in one continuous line as well. Much like the *ℓ*, you can either draw the *ℓ* with a point or loop at the top. For the pointed version, push the entrance stroke

up from the baseline to the waistline. Without picking up your nib, pull the stroke down, applying pressure, creating a small compound curve that traces over a small part of the top of your entrance stroke, then pulls down slightly to the right. When you get to the baseline, curve the line in clockwise to connect to your entrance stroke. Retrace that line as you draw an exit stroke. If the counter of your *l* looks too small, you might not have rounded that compound curve enough when you were creating the downstroke on the belly of the letter.

For the second version, we are not only going to add a loop at the top—we are also going to add a loop on the exit stroke. Push the line up from the baseline slightly past the waistline, loop up and counter clockwise, then pull the stroke down in a compound curve, applying pressure. Release pressure as you near the baseline, rounding out in a clockwise direction. Before you reach the entrance stroke of the letter, curve up slightly higher than the baseline and cross over the belly of your *l*, ending with an exit stroke out to the right. This is a similar exit stroke to the one we saw in the *b* and the *p*; do you remember the 2 shape?

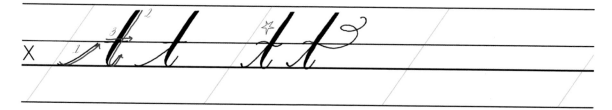

Now for the *t*. After you draw the entrance stroke from the baseline to the waistline, pick up your nib and draw a shaded downstroke from the ascender line down to the baseline. Release pressure when you get close to the baseline, curving the line out to an exit stroke. The simplest crossbar (this is the horizontal line that crosses the letter *t*) is just a straight line across the waistline of the letter. You could reposition the crossbar higher or lower on the letter to make it look slightly different. As a bonus, you can have some fun with that crossbar by making it slightly curved or looped and flourished.

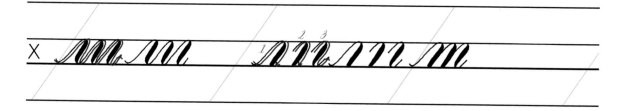

The _m_ is a letter where you can quickly see the difference it makes if you pick up your nib or not. The first version is very similar to the rollercoaster warm-up we did on page 32. Push the line up from the baseline to the waistline and curve down, applying pressure, releasing pressure before you get to the baseline. Then push the stroke back up to the waistline, curving down again and repeating all of that once more.

Now, try writing it this way: Pick up your nib while you're drawing the letter so you create three separate shapes. First, create one shape that looks like a mountain, by pushing the line from the baseline to the waistline, curving around and pulling the thick downstroke to the baseline. Pick up your nib and start about halfway in your x-height space, pushing up to the waistline and curving down to the baseline. This shape looks a lot like a cane. Pick up your nib once more and do the same stroke again, except when you get to the baseline, curve back up and out to the right for an exit stroke.

See the difference? The second version has less negative space around the shapes of the letter.

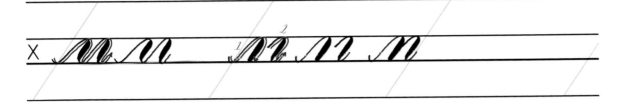

Try this same exercise to make two versions of the letter _n_, which is basically like half of the letter _m_. You're simply going to finish that m rollercoaster early, or cut out the second cane shape from the _m_.

The _u_ is just an upside down _n_. Start right beneath the waistline, then push up toward the waistline and curve down. Apply pressure until you get close to the baseline, release pressure, and curve up with a thin hairline about halfway into your x-height. Pick up your

nib, then pull a downstroke to create a stem from the waistline to the baseline, making sure it connects to your first stroke. Curve up for your exit stroke.

The End of the Alphabet

X

Are you starting to get a hang of the letters? Let's finish off the rest of the alphabet. The *v* and *y* are pretty straightforward, as you can write them each in one stroke. For the *v*, start about halfway in your x-height space for your entrance stroke. Push up to the waistline, and without picking up your nib, pull the stroke down to the baseline, applying pressure. Only round the bottom slightly, as this should look like more of a point than the bottom of the *u*. Push the line back up to the waistline, then make a little curved exit stroke toward the right, using just the point of your nib.

X

You're going to draw something very similar for the *u*, but when you get to the baseline, give it a more rounded bottom before pushing back up to the waistline. Do the same stroke once more to create the second section of the *u*. While you could do the same exit stroke as the *v*, I'm showing you a version with a looped exit stroke for an alternative. When you get to the waistline, simply loop counter clockwise, crossing over and out to the right.

X *y y y*

The *y* is going to have that same start as the u, but the descender stem should remind you more of letters like *g* and *f*. The stem loops in a clockwise direction and crosses over itself. To start the letter, make an entrance stroke about halfway in your x-height space, push the stroke up to the waistline, curve down to the right, then pull the stroke down to the baseline and curve back up to the waistline. Pick up your pen and start your downstroke stem at the waistline, pull the stroke down to the descender line, then loop clockwise up and over to the right. Cross over your stem and the baseline before finishing halfway up the x-height space. You can also try the *y* without picking up your nib; this may create a more rounded top to the stem.

X *z z*

The *z* almost looks like an elongated 3, doesn't it? Start at the baseline and push up to the waistline, then curve back down to the baseline. Curve slightly inward and down to the descender line, then loop clockwise over the stem and back up to the baseline. End your exit stroke about halfway into the x-height space. You could add a loop within the shape of the *z*, if you wanted. You could also make the *z* look like it does in print writing, but then it's trickier to connect to other letters.

X *x x x x x*

And finally, the _v_: a funny little letter that you may not use very much, but it's so exciting when you get to! One way you can make the _v_ is by first drawing a backward c-shape and then a typical c-shape. Start right beneath the waistline, push up, and curve in a clockwise direction down to the baseline and back up into the x-height space. Pick up your nib and draw the second c-shape directly next to it: Start right beneath the waistline again, push up, and curve in a counter-clockwise direction to the baseline, then back up into the x-height space. Draw the two shapes so they barely touch.

Another way to make an _v_ is to first push a line from either the waistline or directly underneath it up and over, pulling the stroke down to the baseline, and rounding out to an exit stroke that pushes up into the x-height space. Then add the crossbar by starting at the baseline and pushing it up diagonally, crossing over the center of your first stroke.

Putting It All Together

Use the rest of the lines to draw your favorite letters, or maybe the ones with which you struggled the most.

Here are all the letters together, both with guidelines and without, for you to reference, trace, and practice.

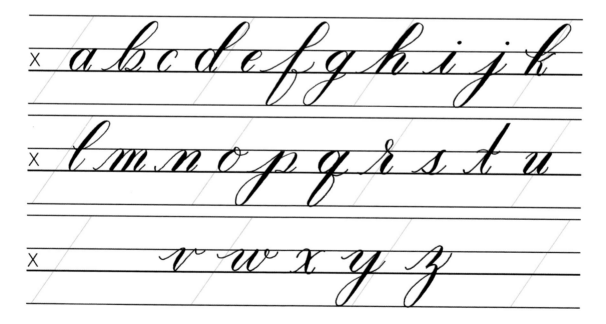

a b c d e f g h i j k

l m n o p q r s t u

v w x y z

Learning Majuscules

Now that you've learned your minuscules, let's try the majuscules. Just like with the minuscules, follow the direction of the arrow. Remember, the head of the arrow is the end of the stroke, so start where there isn't a point. As you can see, you can make most of the letterforms in one continuous stroke, if you'd like.

x *A B C D E F G H I*

x *J K L M N O P Q R*

x *S T U V W X Y Z*

x *A B C D E F G H I*

x *J K L M N O P Q R*

x *S T U V W X Y Z*

A B C D E F G H I

J K L M N O P Q R

S T U V W X Y Z

You'll notice that in this particular majuscule alphabet, I only have the *J* and the *Z* dropping to the descender line. Sometimes, I'll make the *G* and the *Y* do the same.

That tick mark on the second stroke of the *T* is something we haven't seen yet. You can either cross the *T* with a straight line, or one that's slightly curved. You could either end that stroke normally, with a fanciful loop, or with a tiny tick of the nib, like you see here. To make the tick mark, apply pressure with the point of the nib, almost like you're dabbing off extra ink, and then quickly release the pressure and nib from the paper. It's a quick motion that creates an upside-down raindrop shape like you made in your very first pen warm-up on page 30.

For the *K*, you'll notice that the third stroke is in front of the letter. I know that might seem odd, but that is how I'll sometimes draw the letter, and I want you to realize that you can draw the shapes of the letters in whatever order feels comfortable to you. For instance, when I'm drawing an ampersand, I actually do it in two parts. I start from the top because it helps me make the right shape.

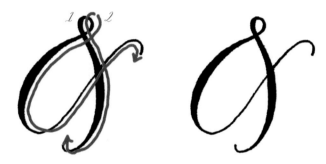

Here are some number styles and common punctuation shapes, including another version of the ampersand, which is a symbol for the word "and."

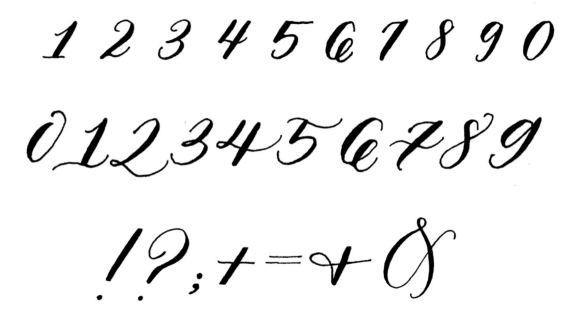

Great job! Are you ready to customize your letters and make some more beautiful calligraphy? Then keep reading.

Chapter 5

Developing Your Style

Now that you've learned all of your letters, it's time to use them! You can start writing messages, designing monograms, and doing all of the fun activities in Chapter 7. But first, you have to practice stringing all of the letters together. In this chapter, you'll learn a bunch of fun exercises to help you get used to connecting your letterforms.

One of the fun ways to practice your minuscules is to make calligraphy necklaces, where you write the alphabet with all the letters connecting. You'll have to re-dip your nib into the ink as you go. If your ink runs out mid-letter, dip again, start where you left off, and keep going.

abcdefghijklmnopqrstuvwxyz

I made the crossbar of the *t* really long, just for fun.

Here are some other fun things to practice.

Fun and Friendly *Calligraphy* for Kids

One of my favorite words to write and practice is minimum. Can you guess what I did differently in versions 1 and 2?

minimum

minimum

In the first version, I never picked up the nib except at the end, when I drew the dots over the *i*'s. Try it out; you'll realize it's a great exercise, as you have to really pay attention to where you are in the word because a lot of the letterforms look like one another. In the second version, I picked up my pen, which helps make a word like this look a bit more legible. It allowed me to square off the tops of the letters more, as well.

Extra help: Squaring off the tops and bottoms of letters, or giving them that straight edge, requires a lot of practice. You can either go back once you finish a word and square them off, or you can do it as you go by really paying attention to the pressure you're applying to your nib's tines. Try placing your nib on a horizontal line like your waistline. Pause and apply pressure so the nibs separate to the desired width. If you pull the stroke down before the tines are fully open, the top of the stroke will appear rounded or pointy. (For the record, this is totally fine, it just gives your letters a different look.) Once the tines are separated, maintain that pressure and pull the pen down. When you reach the baseline or the desired length, pause, and slowly release the pressure of the right tine by keeping some pressure on the left tine to keep it stationary. The right tine will close to the left and square off the bottom.

Many people find calligraphy to be extremely relaxing because you're unable to think about anything else except what your hand is creating on the paper. You switch off your mental to-

do list and other noise (homework? what's homework?), and all you can hear is the scratch of the nib on the paper as you push and pull the stroke of the ink line.

An important thing to keep in mind when you start connecting letterforms is that you should move much more slowly when writing calligraphy than you would with, say, a pencil or gel pen. Control is key. Since we're drawing the letters instead of writing them, and since we're using these special tools, it requires a slower rhythm, one that you'll feel when putting the letters into words and phrases.

Sometimes, it's helpful to count "1, 2, 3" in your head for each letter, giving the same amount of pause in the connector lines to keep that pace consistent throughout. Or, instead of counting, try saying "push and pull" in your head (or out loud!) to really feel the nib working its magic on the paper. As you go along, you'll start to feel when the ink is running out and you need to re-dip. You'll also notice when your pen is grabbing too much ink and it's time to clean it off completely and start fresh.

Staying Consistent

As I said before, in modern calligraphy, you can do whatever you want. I'm not here to tell you that your letters are too fat, too skinny, too round, too pointy, too slanted, too upright, too light, too dark. You get to decide what you want your styles to look like. But, I will admit that there's at least one thing you should strive for within your lettering that is really going to make them visually appealing: consistency.

Look at these three versions of the word "calligraphy." The first is like the style we just practiced. The second has more of an uneven, or dancing baseline, meaning that not all of the letters are resting on the baseline we used in the guidelines. It has a looser, more whimsical appearance. The last option is more of an extreme version of the same idea, where the letters feel pointy and stretched out.

All of these work because they're consistent. But what about this?

The mix of styles in this case doesn't really feel intentional. I'll show you later how to get creative with your lettering while still being consistent.

What else is important? Spacing!

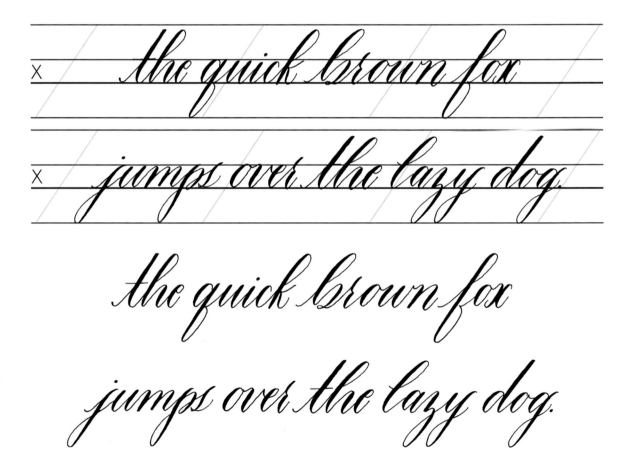

It shouldn't take you five times as long to read a word because of odd spacing. Your spacing should also be consistent.

To practice consistency, let's try writing a sentence in all minuscules.

Fun and Friendly *Calligraphy* for Kids

Now practice some of these fun sentences, adding your majuscule letters.

1. Sphinx of black quartz, judge my vow.

2. Two driven jocks help fax my big quiz.

3. Five quacking zephyrs jolt my wax bed.

4. Puzzled women bequeath jerks every exotic gift.

5. Heavy boxes perform quick waltzes and jigs.

6. Jinxed wizards pluck ivy from the big quilt.

7. Crazy Fredrick bought many very exquisite opal jewels.

8. We promptly judged antique ivory buckles for the next prize.

9. Jaded zombies acted quaintly but kept driving their own oxen forward.

10. The job requires extra pluck and zeal from every young wage earner.

These 10 sentences, plus the sentence on the previous page, are all pretty outrageous, aren't they? Can you figure out what's similar about them? Look closely...

They each contain every single letter of the alphabet, which makes them all pangrams!

"The quick brown fox jumps over the lazy dog" is one of the most common pangrams. On the next page, there are two new versions of that sentence: One has a dancing, uneven baseline and one is in a vertical style, where I ignored the slant line and made the letters appear upright.

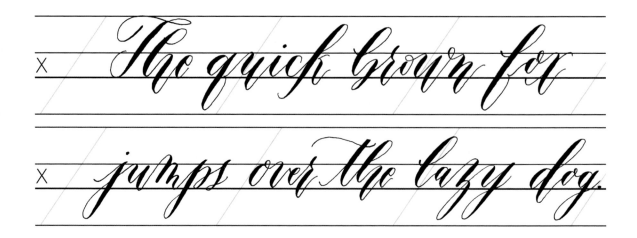

X The quick brown fox

X jumps over the lazy dog.

X The quick brown fox

X jumps over the lazy dog.

Creating Your Style

It's fun to think of different ways to make your letters look. The less you pick up your nib, the more flowy and loose your letters look, especially if you keep that baseline loose as well. Check out this style.

a b c d e f g h i j

k l m n o p q r s t u

v w x y z

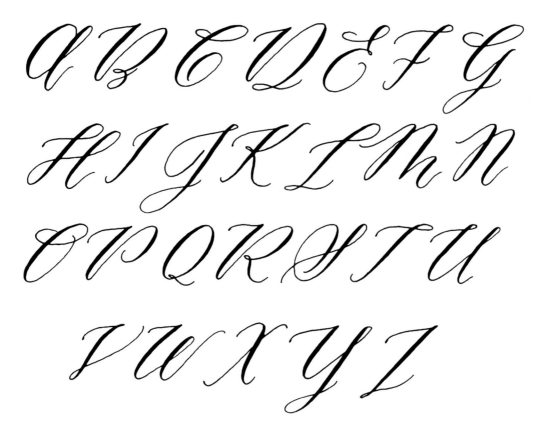

A B C D E F G
H I J K L M N
O P Q R S T U
V W X Y Z

Now try doing an alphabet necklace in this looser style.

abcdefghijklmnopqrstuvwxyz

What if we wanted to make the majuscules slightly more flourished than the ones we did before? Try these. (Learn more about flourishes on page 109.)

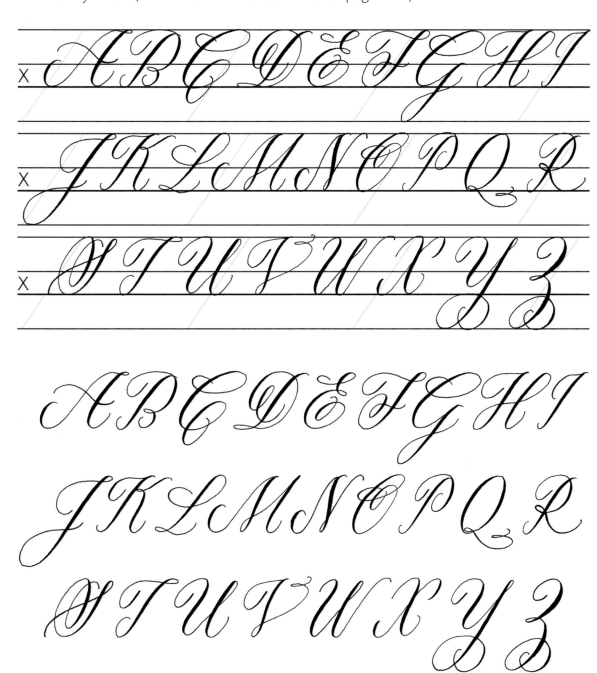

Here are a couple more versions to try:

ABCDEFGHI
JKLMNOPQ
RSTUVWXYZ

In this majuscule alphabet, I added parallel lines next to some of the strokes, which adds a bolder and fanciful look. Someone who hasn't practiced the letterforms in the book thus far might look at this alphabet and not know where to start. However, once you understand that the thicker swells of ink are all downstrokes, that you can create the hairline strokes in any direction, and you can split the letterforms up into the shapes you see within them, you'll be prepared for trying out and practicing new styles.

ABCDEFGHIJKL
MNOPQRSTUVWXYZ

In this majuscule alphabet, I pretended someone was squeezing the letters. They appear skinnier and more condensed, which means I made the spacing inside and around the letter strokes much smaller.

Fun and Friendly *Calligraphy* for Kids

Next, I'd like to share examples of a vertical, upright alphabet that doesn't use a slant line. Here are both minuscules and majuscules, with flourishes added to the majuscules. While you can certainly use your oblique pen holder to create this style, I'd suggest trying out your straight pen holder. Remove your nib from your oblique pen holder and insert it into the end of the straight holder. Make sure the whale hole and imprint are facing upward. While the shape of the oblique pen holder helps you write on an angle, a straight pen holder is helpful when creating vertical lines.

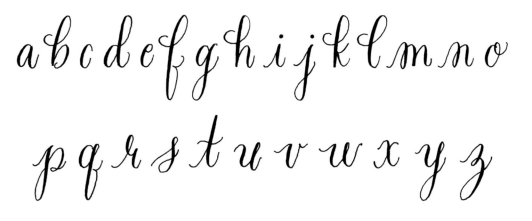

I want you to take note of letters you see during your daily life that inspire you. Perhaps you'll notice an interesting letterform on a building awning or in a brand logo. One day you might see something that isn't even a letter at all, but the shape sure looks like one. Or maybe you'll see how someone else writes a certain letter and you'll find that your finger immediately traces the air as you imagine the direction of your pen stroke.

Remember earlier, when we talked about staying consistent? There's one instance where breaking the rule of consistency is something I personally think looks really cool: when you intentionally make every letter look different. As you find those letterforms you like, jot them down and revisit them and make a list of some of your favorites.

Here are some of mine.

A A A B B I C C C

D D D E E Z F F

G Y Y H H H I I I

I J J K K L L L

M M M N N N O O O

P P P Q Q 2 R R R

S S S T T T U U U

V D V W W W X X X

Y Y Y Z Z Z

Brush Pen Calligraphy

Now that we've talked a bit about creating a personal style, I want to introduce you to brush pen calligraphy, which is where you can apply all of the same pressure techniques we've learned so far, but with brush pens instead of pointed pens. You've already learned the hard part—way to go!

I'm going to show you this with a type of marker you probably didn't even know could be a brush pen, and one that you probably already have in your art stash...a Crayola marker.

Try these warm-ups and apply the same pressure and release you did with the pointed pen. When you apply pressure to the marker, it will use more of the edge, which creates a thicker line than the very tip does.

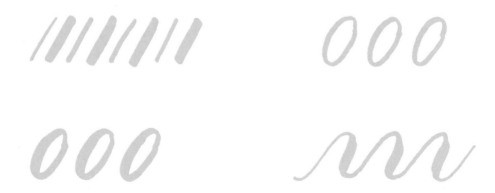

You'll notice that it's easier to write slightly bigger with the markers. Try and draw these minuscules with your marker.

a b c d e f g h

i j k l m n o p

q r s t u

v w x y z

Now, try the majuscules.

ABCDEFGHI

JKLMNOPQR

STUVWXYZ

It's fun to try out different brush pens and see what line thickness you prefer. If you want another brush pen that is good for big lettering like the Crayola markers are, but has more of a flexible brush point, try Tombow. The cool thing about some of their brush pens is that they have a dual tip, meaning there's a small tip on the other side that you can use for small, detailed writing.

Faber-Castell makes Pitt artist brush pens in different sizes as well. One of my favorite brush pens for slightly smaller writing is the Pentel Fude Touch Sign Pen. The tip is very durable, and you can still achieve varying line widths based on pressure.

a b c d e f g h i j k

l m n o p q r s t u

v w x y z

A B C D E F G H I

J K L M N O P Q R

S T U V W X Y Z

While you obviously can't get that same gorgeous, thin hairline stroke that you get with pointed pen calligraphy, brush calligraphy is beautiful in its own way and is an incredible technique to practice. You can also take the fine-point tip of a Tombow brush pen or a Micron pen and write a separate alphabet to pair with your brush calligraphy. I love how simple and thin block letters look in contrast to the looser, whimsical brush calligraphy.

ABCDEFGHIJKLMNOPQRSTUVWXYZ

Extra help: Want to make those letters really consistent and all the same size? A trick is to draw two light pencil lines—one for the baseline and one for the top.

Remember on page 62, where I talked about writing letters different ways but still being consistent? Pick a word that's fairly long and uses some of the same letters more than once.

Congratulations

Congratulations

Here are two examples of "Congratulations," drawn with the Pentel brush pen. I changed them up a bit in each one, but do you see how I made the *o*'s, the *n*'s, the *g*'s, and the *t*'s the same within the word? You can do this, or you can make every single letter completely different from one another.

Mixing Ink for Pointed Pen Calligraphy

Let's say you want to write in pointed pen calligraphy using something other than black ink. Your other options are white ink, colored ink, and metallic ink. I listed my

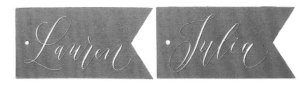

favorite white ink on page 12. It comes in a jar, but it's extremely thick and goopy. The first time I tried it, I had no idea I had to thin it out, and I figured I ordered a bad batch. Luckily, I eventually learned this helpful step: Pour or scoop some of the thick white ink into an ink holder, slowly add water (distilled water is best, but normal tap water will do), and stir with a paintbrush or the small end of your calligraphy pen, which will dilute it. To dilute the mixture means to make it thinner so it can flow through the nib onto the paper. Some calligraphers say they like their mixed ink consistency to be that of heavy whipping cream. If you're not sure what that looks like, aim for the consistency of thick whole milk. Test your ink flow on a scratch sheet to know when you have the right ratio of ink to water.

There are brands out there that make calligraphy ink in a variety of pre-mixed colors, but the actual shades are often limited, so I prefer to mix my own ink colors using gouache. Gouache is an opaque watercolor paint that you can buy in tubes. Squeeze a little gouache into the container you wish to use, like a large dinky dip. Start with just a little. Use an eyedropper or pipette to add water slowly, and then stir. Just like with mixing white ink, you can use a paintbrush or the small end of your calligraphy pen. Try dipping your nib into the mixture and see if you get a smooth line on your scratch sheet. You should be good to go once you get the consistency right, but if the ink isn't flowing well from the nib, try adding a couple drops of gum arabic. Is your color slightly off from what you want? Add a tiny bit of gouache in a different color! A lot of color mixing is trial and error, but it's helpful to keep in mind the basic rules of mixing primary colors: Mixing reds and blues make purple, mixing yellows and blues make green, and mixing reds and yellows make orange.

Metallic ink comes in either pre-mixed jars, in a powdered pigment, or in the form of pods. If you're mixing with Pearl Ex Powdered Pigment (see page 13), you'll want to mix about four parts water, four parts pigment, and one part gum arabic (i.e., 1 teaspoon water, 1 teaspoon pigment, and ¼ teaspoon gum arabic). The sediment of a metallic ink can settle

after a little bit, so you'll have to keep stirring the mixture every few minutes. The magic of metallic ink is when you look at it from an angle in the light—the ink glows!

If you're using palette pods of ink, all you have to do is add water with a paintbrush and paint the color or metallic shade onto your nib. This takes a little longer than dipping your ink into some sort of container, so I wouldn't suggest this for a project where you're writing a bunch. But I must say, palettes are wonderful to bring with you when you travel!

Keep in mind that some inks smear more easily than others once dry, especially during the warmer and more humid months. It's always a smart idea to store and mail something accordingly, adding extra protection just in case.

Also, don't feel like you can only write on paper. Here I used my same favorite white ink, but on sea glass! Lettering on uneven surfaces never looks as smooth as it does on paper, but gosh, it is fun.

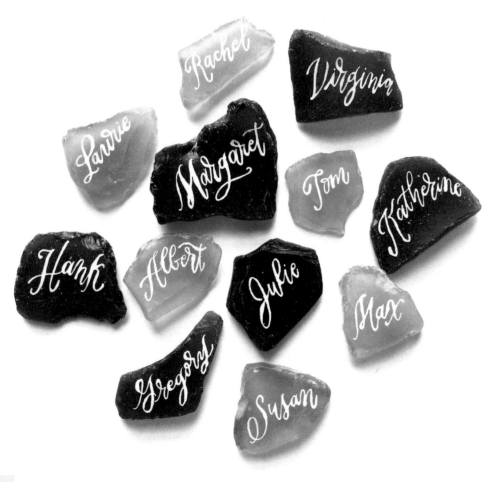

Fun and Friendly *Calligraphy* for Kids

Chapter 6

Time to Practice

Bravo! I'm so very proud of you for making it through the most challenging part of this book and pushing yourself to try a new skill. You may not even realize just how much you have already learned, so let's do a little recap, shall we?

You learned the terminology and tools involved in the practice of calligraphy, how to set up your workspace, and the best ways to prepare your tools, hands, and arms to achieve the best results. You learned how to properly hold your writing utensils and care for your tools, as well as how to draw the shapes found in all of the minuscule and majuscule letters of the alphabet. You received the helpful advice about angles and pressure that I really wish I had known earlier. You have tried various alphabet styles, and written with pointed pens and brush pens, and have started to recognize ways in which you can alter and personalize your letters and writing style. Whew! You've earned a gold star, my friend, and I very much hope you've had some fun along the way.

There is one secret key, however, to remembering what you've learned, building that muscle memory in your hand for different shapes and styles, and improving your calligraphy skills: practice. Yep, you're going to need to practice, then practice again, then practice some more. Even the best calligraphers in the world continue to practice, practice, practice.

Here are three don'ts to remember while you practice:

1. Don't make perfection your goal, because "perfect calligraphy" doesn't exist.

2. Don't compare your calligraphy to someone else's. Focus on your own calligraphy journey and simply aim to draw that line and shape and letter better than you did on your last attempts.

3. Don't forget that "better" can simply mean "how you like it."

I don't want your calligraphy practice to feel like extra homework. This should be an escape from all that; it should be a reward to practice once you finish your school work. Go back through and redo the exercises in Chapters 3, 4, and 5 of this book. Create fun drills for yourself by drawing certain lines and shapes and letters, over and over, until you feel you've got it right. Look at the month ahead and assign a letter to each day. On the first day, practice the letter *a*; on the second day practice *b*, and so forth. Once you feel like you've got the basic letter shape down, try writing the letter in as many styles as your imagination can dream up! Don't forget to practice pangrams and calligraphy necklaces. When you're finished practicing for the day, take a marker and star all of your favorite letters or words. Circle the ones you want to work on. Next time you sit down to practice, take a look at these for inspiration. I assure you, practice makes progress, and the progress you'll make will be incredibly rewarding.

These templates can be used as is, though I recommend using tracing paper or making copies.

X X X X X

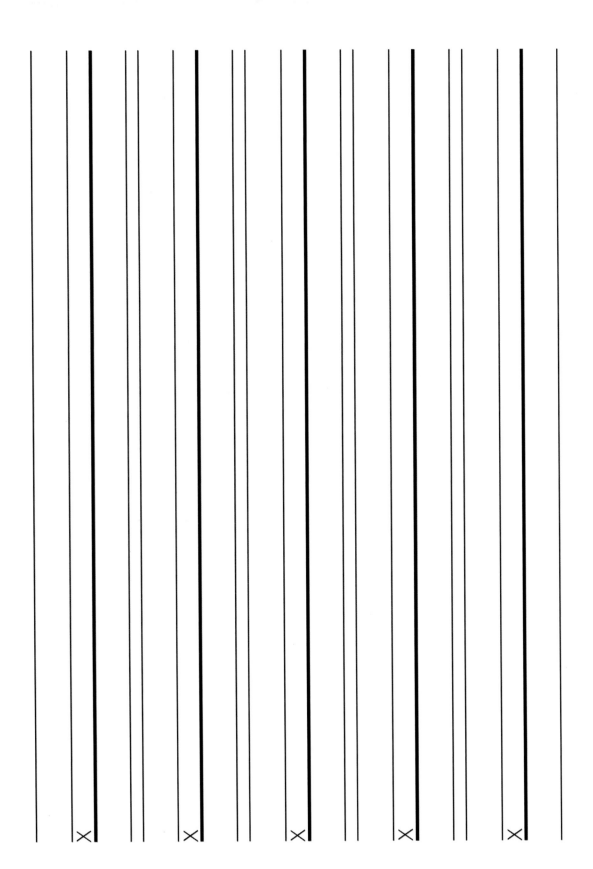

Chapter 7

Ways to Use Calligraphy

At this point, you probably realize that calligraphy is two things: beautiful and fun.

But I want to discuss a third thing about calligraphy, and about handwriting and penmanship in general: It's important.

We live in a time when emails and text messages have replaced our handwritten forms of communication. On one hand, this allows us to communicate more quickly and with more people at once (which is terrific!), but the specialness has really been stripped from the letterforms themselves.

It used to be that if people were separated by distance, they wrote handwritten notes to one another in their one-of-a-kind penmanship, expressing their thoughts and feelings through something they physically put on a piece of paper. Seems a wee bit more sacred than a string of heart-eye emojis, yes?

Many schools are substituting handwriting curriculum with computer-based lessons, and some kids are having a harder time using a pen or pencil than a keyboard or touchscreen. (Not you though, right?)

Embracing technological advances is important in its own right, but we can't neglect the important communication and artistic tool that is handwriting. You should want to be able

to read and understand the penned letters from history, and you should also want to contribute your own.

Since handwriting is much like a fingerprint, where everyone's exact style is slightly different, it's one of the most personal ways to interact and to share your story. Have you ever received a note from someone and known exactly who wrote it before you even read it because you recognized their handwriting? Take a second to really think about how cool that is.

As Steve Carell has pointed out, "Sending a handwritten letter is becoming such an anomaly. It's disappearing. My mom is the only one who still writes me letters. And there's something visceral about opening a letter—I see her on the page. I see her in her handwriting."

Now that you fully understand the importance of handwriting, especially beautiful writing like calligraphy, you might be wondering what ways you can use and practice this newfound skill of yours. If you're not spending much time practicing it at school, then I really encourage you to do so at home.

Thank-You Notes

At some point in your life, you'll most likely have the exciting task of finding a job. As you submit applications, you may not notice penmanship listed as a required skill, but as we know, having good handwriting and knowing how to use it is a critical communication skill. It's also an incredible way to set yourself apart. If your potential employer interviews three equally qualified candidates and you're the only person to send them a handwritten thank-you note, you will be leaving the best final impression.

However, it's key to remember that thank-you notes are not about you. Sure, they certainly might be to your advantage in a situation like an interview, but thank-you notes are vital in expressing gratitude toward others. They should be about the people who earned that gratitude.

If you're fortunate, you are going to encounter many situations in life where people have taken time out of their busy schedules in your honor, whether it's meeting with you about a job, hosting you at an event, helping you with something, giving you a gift, and so forth. It's very important to then take the time to thank that person for their thoughtfulness.

For instance, when someone gives you a birthday present, think about the time they spent figuring out what to get you, earning the money to purchase the present (or maybe they made it by hand!), wrapping the gift, and then bringing you the present or waiting in line to mail it to you. It sure makes you feel really special, doesn't it? Letting that person know how much you appreciate that effort and care is not only mannerly, it's the nice thing to do. And a thank-you note is a small but perfect way to let them know. You also somewhat reciprocate that caring sentiment by taking a little time to sit down and acknowledge their generosity.

When someone receives a thank-you note, they feel valued and appreciated. On the other hand, when someone doesn't receive a thank-you note, especially if you weren't able to thank them in person, they might wonder if you noticed what they did. Although thanking someone in person or in an email is obviously better than not mentioning it at all, nothing will ever be as special as a handwritten thank-you note.

Here are a few helpful tips for writing a thoughtful thank-you note:

1. Start by adding a date at the top. (You should always date anything you write!)

2. Next, add a greeting with their name, or with their nickname, as a first line followed by a comma. I like to say Dear _____, as "dear" is a word of affection and respect that can be used for both personal and formal letters.

3. Then, express your gratitude. Go on and directly thank them. Be specific about what they did that was so nice or how you'll use the gift.

4. Once you've finished thanking them, add in something else while you're at it! Chime in about the next time you'll see or talk to them, or perhaps mention something that you're excitedly anticipating. Thank-you notes should reflect and evoke the feelings their generosity gave you, and thus, they should be happy and uplifting.

5. Finally, circle back to the purpose of your note by thanking them once more. Depending on your relationship to the person, you can sign off different ways. Here are a few of my favorites for signing the end of a thank-you note:

> Sincerely,

> Best,

> With gratitude,

> Love,

Don't forget the commas!

6. Sign your name at the very end.

Customize Your Notes

Do you like to draw? Draw them a picture they can hang on their fridge either on the card or on a separate piece of paper. Good gracious, they will love it. Here's an example:

May 25, 2020

Dear Grandma and Grandpa,

Thank you so much for the baseball cap. I absolutely love it! How did you know the Yankees are my favorite team? I can't wait to go to a game this summer so I can wear my new hat.

I'm really excited to visit you next month and stay at your house. You guys always make the best blueberry pancakes. I hope you have a fun summer until then!

Thank you again for remembering my birthday and sending such a cool gift. That was really thoughtful. I love you!

Love,
James

Imagine being Grandma and Grandpa reading something like that. They would smile so big!

Now imagine the difference of reading something without much thought, like this:

That one doesn't really evoke any sort of happy emotion, does it?

If you're going to write a note, make sure you actually give it some thought and care. It doesn't mean you have to write the letter in pointed pen calligraphy (although what great practice that would be!). The first example was written rather quickly, and with a normal ol' pencil.

Pen-Pal Challenge

Have you ever had a pen-pal? A pen-pal is someone with whom you exchange letters. You take turns writing so once you receive a letter, you know it's your turn to send one back. If you don't already have a pen-pal, I challenge you to find one. Send the first letter and explain that you'd like to start writing back and forth.

A pen-pal is preferably someone you know and love, but you don't get to see very often. It could be a relative or a friend that lives far away, but it could also be anyone that treasures beautiful handwriting and note-writing as much as you.

Although you can always communicate with your family and friends through phone or email, nothing is as exciting as receiving a hand-lettered note in the mail. Imagine how special they'll feel when they receive something from you, a calligrapher!

An easy format for writing a letter, like one to a pen-pal, is to start with a greeting, just like we discussed for the thank-you notes. Dedicate your first paragraph to talking about the other person. Ask them how they are, or respond to specific things they mentioned about themselves in their last letter to you. After that, answer their questions about yourself and what you're up to, and share something new. Bring up anything else you want them to write about in their response, and always sign off with a happy thought, a closing, and your signature. Don't forget to add the date somewhere on the note so they know when you wrote it!

> **Did you know:** P.S. stands for "postscript," which means an additional statement. If you think of something you wanted to write after you finish the letter, you can write "P.S." at the bottom or on the back, and include it.

If you choose to be an A+ calligraphy student and write a letter to your pen-pal in pointed pen calligraphy, make sure you let the letter completely dry before you fold it and place it inside an envelope. Also, it's helpful to use a guard sheet between your hand and the final piece of paper to protect it, no matter what writing medium you use.

Other Notes and Letters

If you know of someone who is experiencing something really exciting in their life, whether it's making a sport's team, being elected to serve on student council, a graduation, a new job, a marriage, a new baby, a retirement, recovery from an illness, or any other personal milestone, a congratulatory handwritten letter is such a wonderful way to share that you're celebrating them.

Holidays are also wonderful opportunities to reach out to your loved ones with a handwritten note full of calligraphed love.

Sympathy letters are often difficult to write, but they are very important. Send a letter to someone if they are going through something hard or if they've lost a loved one. Your tone should be much more somber in sympathy notes than, say, in a congratulatory note. Avoid exclamation points, and if you can't think of anything to write, you can simply say you're sorry. The gesture is what really matters in this instance.

Last, but certainly not least, birthdays are the perfect reason to send someone a beautiful hand-lettered card in the mail to wish them a happy day and year ahead. Keep a small calendar or list you can reference year to year with all of your friends' and family members' birthdays, and work on them at the beginning of each month.

Extra help: Take a piece of colorful construction paper and fold it twice so it can easily fit inside the envelope. Calligraph a greeting on the front page, and once that's dry, flip open the front and write your longer message inside. The extra fold of the paper will help prevent the ink from bleeding through to where you're writing the note.

Envelopes

Once you've finished your letter, whether it's a thank-you note, a birthday card, or a thinking-of-you note to your pen pal, it's time to address the envelope that will transport your note to where it needs to go, safe and sound.

When putting the name on your envelope, you can either just put their first and last name, or you can be more formal and use titles, such as Miss, Ms., Mr., Mrs., etc. If someone is a medical doctor or has a PhD, you can use Dr. The most important thing is to make sure you spell everything correctly so your note gets to the right person. You can address your envelope however you want, as long as it's legible for the post office and the information is in the right places.

ENVELOPE FRONT:

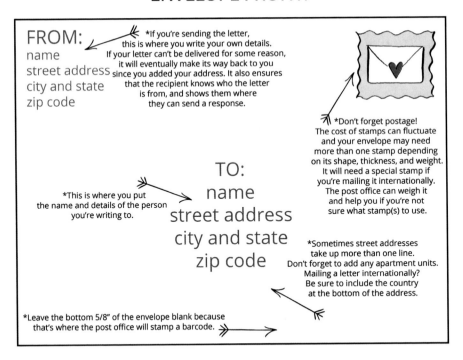

FROM:
name
street address
city and state
zip code

*If you're sending the letter, this is where you write your own details. If your letter can't be delivered for some reason, it will eventually make its way back to you since you added your address. It also ensures that the recipient knows who the letter is from, and shows them where they can send a response.

*Don't forget postage! The cost of stamps can fluctuate and your envelope may need more than one stamp depending on its shape, thickness, and weight. It will need a special stamp if you're mailing it internationally. The post office can weigh it and help you if you're not sure what stamp(s) to use.

TO:
name
street address
city and state
zip code

*This is where you put the name and details of the person you're writing to.

*Sometimes street addresses take up more than one line. Don't forget to add any apartment units. Mailing a letter internationally? Be sure to include the country at the bottom of the address.

*Leave the bottom 5/8" of the envelope blank because that's where the post office will stamp a barcode.

ENVELOPE BACK:

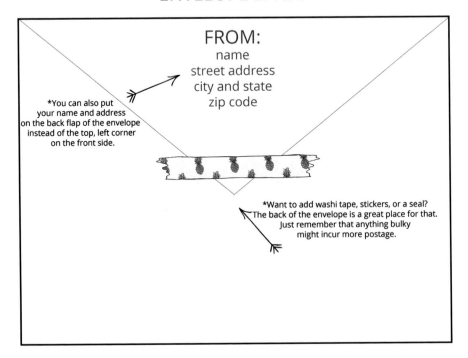

FROM:
name
street address
city and state
zip code

*You can also put your name and address on the back flap of the envelope instead of the top, left corner on the front side.

*Want to add washi tape, stickers, or a seal? The back of the envelope is a great place for that. Just remember that anything bulky might incur more postage.

Fun and Friendly *Calligraphy* for Kids

If you want your lines to be diagonal or wavy, go for it! If you want to keep your lines straight, here are five tips to help.

1. If your envelope is white or see-through, take one of your lined pieces of notebook paper (or a copy of your guidelines) and fold it lengthwise so it fits inside the envelope.

2. If you can't quite see the lines through the envelope paper, you can use a light box to help. Light boxes are flat glass or plastic surfaces that have an electrical light inside that distributes light evenly across the surface, making whatever you put on top (like a piece of paper) much more see-through. Use a piece of washi tape to hold down your envelope to the light box so it doesn't slide.

3. If your envelope is opaque (not see-through), you can measure and draw lines with a ruler and a pencil. Writing on a dark envelope? Use a white pencil to make your guidelines. Remember to make all of your pencil lines very light, as you'll want to erase them later. Kneaded erasers are best to use for this because they won't leave behind all the residue.

4. An envelope stencil like the Lettermate is a great tool to quickly draw straight lines for an address.

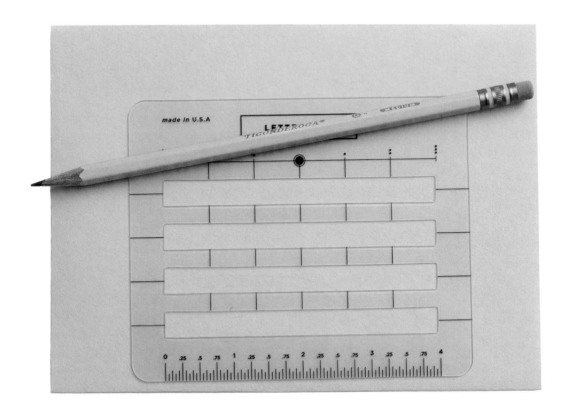

5. Addressing a bunch of envelopes at once and don't want to measure or write guidelines on each one? There's something called a Slider Writer that points a laser line across the envelope. You can manually move the laser down a measured side as you write, which helps you not only keep your lines straight, but equally spaced.

Gifts

Since calligraphy is such a beautiful way to share words, it also makes a terrific gift or keepsake. And a fun way to utilize your calligraphy in a gift is by writing out your favorite quotes or lyrics.

You can use pointed pen calligraphy (remember to leave some room for a mat and a frame!):

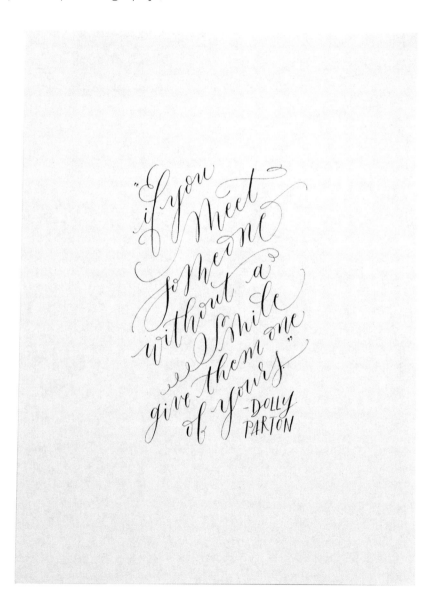

Or, you can pull in some magical color.

Take some watercolor pods and a paintbrush. My favorite brush to use is called a water brush because it actually holds the water inside, so all you have to do is squeeze the body of the pen a little instead of dipping it into water. While you're drawing the words, try dipping your brush into other colors in between shapes and letters, and watch the colors magically mix.

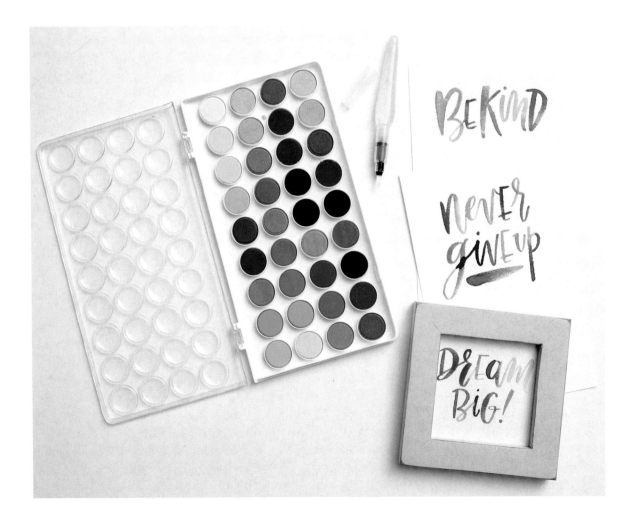

Fun and Friendly Calligraphy for Kids

Stationery and Other Personalized Goods

Calligraphy comes in handy for special events for things like birthday invitations, words of encouragement for a big sports game or competition, as well as gift and favor tags. Even if your family is simply having a small gathering at your house, you could ask if you can make special cards with everyone's name for the occasion. They will love it! One thing is for certain: People adore seeing their names written in calligraphy, and they will be so impressed that you took the time to make something special in their honor.

If you want to create stationery to have on hand, take a dozen of the same stash of blank flat or folded notecards at a time and write your name (or a phrase like "thank you!") at the top and keep in a safe place for when you need them.

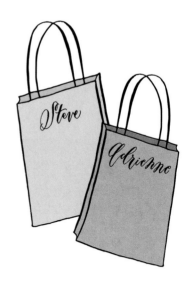

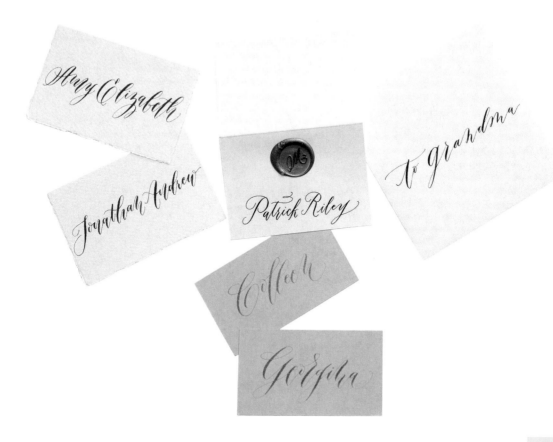

Much like how your calligraphy can be immediately recognizable to others, so can your stationery and the ways in which you decorate the paper. Look in your art supplies and see if you have something you'd like to add. Stickers, rubber stamps, glitter, and tape are all amazing ways to decorate your stationery.

Keep a lookout for random objects you can use to personalize your stationery. If you see a pretty flower loose on the ground in the park, snag it and glue its petals to the front of your cards. The ways in which you can personalize your stationery are endless!

Did you know: Stationery is one of the most commonly misspelled words. People mistakenly use "stationary" to describe paper products, when that spelling actually means "not moving." An easy way to remember that the correct spelling of stationery is with an e is by thinking that e stands for email. There's also an e in paper. Since "standing" has an a, it can help remind you to use an a in stationary when describing something that is standing still. You're going to help by telling all your friends, yes? Thank you.

Monograms

Monograms include two or more of someone's initials and are often used as a way to personalize and decorate an item. Three-initial monograms are the most common. If you keep all of the letters the same size, they should go in order of first, middle, and last name. However, a lot of traditional monograms have the initial of the last name in the middle, slightly bigger than the other two letters.

Let's say your name is Annabelle Caledonia Bartholomew. First of all, oh my, what a long name you have!

Secondly, you're the coolest, because once we put B in the middle, that makes your initials ABC!

You could do something fairly simple like this:

Or, you can make the letters more flourished and overlapped, like this:

My favorite monogram style is something upright, where the middle letter's size difference is a tad exaggerated.

Look how fun something like that looks on stationery.

Signatures and Autographs

Just like how monograms can be a way to personalize something like stationery based on a name, a signature or autograph achieves a similar goal in a much faster manner. The purpose of a signature is to create something that you can write quickly and that would be hard for others to replicate, meaning your signature should be extra distinctive and special.

Have you ever met your favorite athlete or celebrity and asked for an autograph? I've actually run into quite a few celebrities while living in New York City, and I typically become so euphoric and bashful that I can only think of one line to say: "I think you're great." I always wish I would remember to ask for an autograph!

If you've ever seen someone actually sign their signature or autograph, you know it looks a lot like a scribble that takes 1.7 seconds for them to do. Sometimes people add a secret number or a motif, like a line or a special way they dot their *i*.

Here are a few famous autographs:

Martin Luther King Jr.

Princess Diana

Jacqueline Kennedy

Andy Warhol

Audrey Hepburn

Walt Disney

They're all so unique. Do you have a favorite?

Time for you to make your own! Need help coming up with what you want it to look like? Think about the shapes in your name. Are you on a team, and do you want to include your number?

Say your name is John Smith, and you're #5 on your hockey team. You could do something like this, where the *J* starts at the end of your first name and makes one big shape that mirrors the shape in the *J*, giving you a place to put your number.

Or if you wanted a signature that was faster and simpler, you could do something more like these, where that *J* turns into a crossbar for the *t*.

Do you see how in the last version, I only kept some of the more prominent letter shapes to imply what it says?

Have fun coming up with something that feels very you. Once you've decided on one, practice it until you can write it fast, and make it look more or less the same each time.

Logos

Are you on a team or in a club that needs a logo for a sign or t-shirt design? Or perhaps you're in a dance group, or your school choir wants to come up with something eye-catching for their upcoming concert! Pull inspiration from earlier chapters, and create a combination of letterforms that accurately reflect the colors, name, and style of your group.

Flourishing and Drawing

Perhaps the most fun activities you can do with your calligraphy involve drawing and adding flourishes. You can even add them onto your other creations after they're finished!

One helpful way to practice your flourishes is within a grid.

Try going back and forth, then switch the direction. Now do them in the same square, layering the lines. Look at the cool design that creates!

The trick is to turn your paper sideways, or however you need to, so your tines can open evenly and you can pull that thick stroke downward instead of sideways. Remember how the tines of your nib operate as you figure out the best way to draw the shapes.

Let's try loops. Reach for the edges of the square so the loops gradually get bigger and bigger, and then smaller and smaller.

Now, try a loose figure-8 shape, gradually adjusting the size throughout the square to bigger then smaller. For the middle exercise, try and tighten that figure-8 shape so the loops are nearly touching. And with the final exercise, try going in a different direction, and making those figure-8 loops even tighter so they're overlapping.

Extra help: If you're having trouble getting your flourishes to feel smooth, go back to page 20 where you loosened up your arm with pencil oval exercises. It's important to strive for whole-arm movement. If your grip is too tight on the pen, your fingers and wrist will end up doing all the work and inhibiting the full shape of your flourishes.

As your hand becomes accustomed to making these shapes, you'll be able to quickly add one or two flourishes to whatever you're writing and drawing, whether it's a crossbar of a *t* or a swirl beneath your name.

Now try these two without a grid.

Add your name above it!

Getting Fancy with Flourishes

What else can you do with flourishes? You can make beautiful borders to frame letters or quotes! And since I'm super nice, I'm going to teach you a nifty little secret. Decide on one small flourish, make it nice and bold so you can see it through your paper, and then retrace it over and over again to make a bigger bordered frame. You can overlap them, and the border will feel nice and cohesive, and no one will be able to figure out how you did it.

Let's take this flourish. It has some pretty loops and a couple shapes at the bottom. Alone it looks like a very strange , doesn't it?

Now let's repeat it, and overlap it a bit.

Fun and Friendly *Calligraphy* for Kids

Do you see that same shape repeated? You could keep it vertical for a note, or turn it sideways and write your name inside, all big and pretty.

Let's try this shape now. It has a couple of little raindrops drawn in.

Ta-da!

Okay, I know this is really fun. One more. Let's add some teeny-tiny circles to this flourish.

Voila!

How remarkable would that look around a special note?

Your flourishes don't have to be rounded like many of the calligraphy styles are. They can replicate any designs you see in buildings or in nature.

Even something simple like this looks cool because the variation of line width made by your pointed pen adds depth and interest.

You could keep a small notebook of interesting shapes and designs you see. See an interesting leaf or flower? Test your pen and see what it looks like when you draw the shapes you see in them.

Secret Messages

Although it may seem like you need all of your calligraphy supplies on hand to practice or create a masterpiece, always remember that you can improvise with what's around you.

For instance, what if I told you that you could write a magical, secret calligraphy message using only a banana and a toothpick?

Don't believe me? Check this out.

Let's take a toothpick and pretend it's a pen and write a message on the outside of the banana.

Remember how we realized that much of the beauty in calligraphy comes from combining thick and thin lines? Try to remember how these letters would look if we were applying pressure to achieve that variation of line width. We can draw thicker lines by shading them in.

Now here's the magical part. Your message will appear rather faint as you write it, but give it an hour or so, and all of a sudden it will darken and look like this:

Final Thoughts

Calligraphy is a spectacular artistic skill to use throughout life, whether it becomes your hobby, your career, or something you use for special occasions. But you know what? It can also be remarkably frustrating when you're starting out, and you might find yourself wondering if you'll ever get the hang of it. I know, because I've been there. Calligraphy requires a good deal of patience, and it can take a while to teach your hand something that doesn't feel familiar. My biggest tip? Practice. Practice again. And then practice some more.

There are countless historical and modern calligraphy resources beyond this book that I encourage you to read and study, which is something I continue to do as well. We can glean so much by emulating others' work, learning different styles and techniques of creative lettering.

I also urge you to sit down with just your tools, without any guides or references, and simply pull from your imagination. Remember that your uniqueness is your magic, and an original is always worth more than a copy.

Stick with it. When you want to give up, don't. Keep learning. Take pride in your penmanship. Celebrate and preserve the craftsmanship of calligraphy. Send love-filled mail. Create. Make. Give. Contribute lettering to the world that no one else can.

With a very big hug,

Virginia

P.S. I think you're great.

today let us choose happiness

Acknowledgments

As with every worthwhile accomplishment in life, it takes a village.

I will never be able to adequately articulate my gratitude to those who supported this book and my efforts in bringing it to life.

To my terrific young students, thank you for challenging me in the best of ways and being such a wonderful source of inspiration.

To Minnow Park, I am incredibly honored to feature your beautiful photography within these pages, but I feel even more so to have you and Becky's friendship.

To Ray, Casie, Bridget, Shayna, and the entire team at Ulysses Press, I'm so grateful you entrusted me with this tremendous opportunity. This book wouldn't have been possible without your vision and hard work.

To my dear family and friends, you have no idea how much I have appreciated your excitement and encouragement. I am unbelievably blessed to have you all in my life.

To Patrick, thank you for putting up with my late nights of work, for allowing me to turn our tiny abode into an art studio, and for cheering me on every day, every step of the way.

And to God, who planted this dream inside my heart long before it made any sense, glory be to you.

About the Author

a baker whose hobbies include drawing and accessorizing

Virginia Lucas Hart, Halloween, age 3

1. Virginia grew up in rural West Virginia.

2. She never learned how to ride a bike without training wheels because she was too busy drawing and coloring. Country gravel roads didn't really help. Neither did the fact she was a wimp.

3. Her favorite childhood pen-pals were her mother, her three older siblings, and her great aunt Ricky.

4. Virginia skipped kindergarten, became an aunt at the age of seven, and started boarding school at 13. Despite growing up quickly in many respects, she always remained a kid at heart.

5. Virginia quoted the lyrics of "Forever Young" in her valedictory address at Virginia Episcopal School and still gets teary-eyed anytime she hears it.

6. After meeting a boy named Patrick while attending the University of Virginia, she called her mother the next day and declared she'd met her future husband. She married him nine years later.

7. Virginia graduated from UVA in 2007 with degrees in English and Studio Art. A week

later she moved to New York City without a job (or a clue), but with a childhood dream.

8. She worked as an assistant in finance for seven years while taking several art classes on nights and weekends. She met a pointed pen calligrapher in a greeting card class at Parsons, and that's when she became determined to learn.

9. Virginia is hopeful that whenever she upgrades from her Manhattan kitchenette, she'll dedicate more attention to her baking skills. They need it.

10. Her childhood dream was to write a children's book.

Virginia is a member of the International Association of Master Penmen, Engrossers, and Teachers of Handwriting. She has contributed her calligraphy and illustrations to countless special events and has worked with individuals, couples, and brands worldwide. Virginia teaches modern calligraphy to both adults and children, celebrating the beauty and importance of her students' individual styles. Her work has been featured on NBC's *The Today Show*, in *Brides* and *Flutter* magazines, and in several online publications. To learn more about Virginia and her work, visit her website virginialucashart.com.